IMAGES
*of America*

# EDEN PRAIRIE

# MAP OF EDEN PRAIRIE

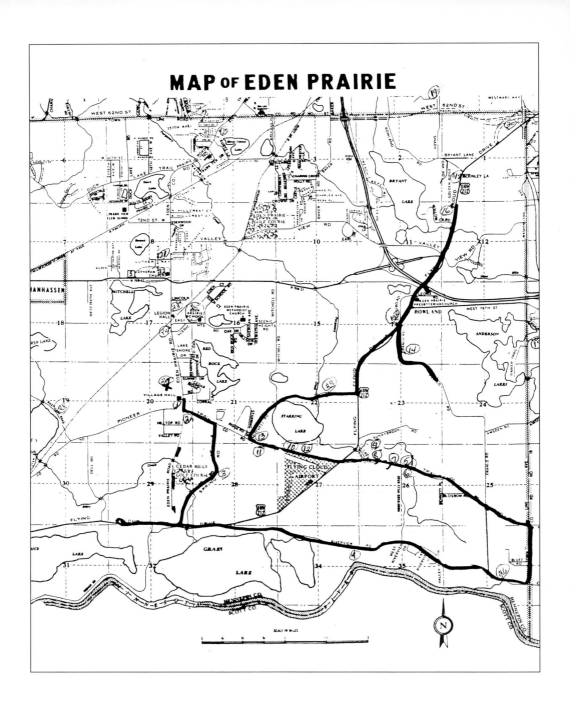

IMAGES
*of America*

# EDEN PRAIRIE

Marie Wittenberg

ARCADIA

Published by Arcadia Publishing,
an imprint of Tempus Publishing, Inc.
Charleston SC, Chicago, Portsmouth NH,
San Francisco

Printed in Great Britain.

Library of Congress Catalog Card Number: Applied For.

For all general information contact Arcadia Publishing at:
Telephone 843-853-2070
Fax 843-853-0044
E-Mail sales@arcadiapublishing.com
For customer service and orders:
Toll-Free 1-888-313-2665

Visit us on the internet at http://www.arcadiapublishing.com

*I am dedicating this book to my family who smiled every time I talked about it and are now as proud of it as I am. Daughter Lori and husband Keith Wolfe, daughter Jill and husband Greg Hules, and grandchildren Matt, Chris, Jeff Stensrud, little Adana Wolfe, and arriving this past year, little Olivia Hules, who I fondly refer to as "Sunshine." Also in memory of my late husband, Dennis, who had as much fun going over all the pictures and stories as I did. And most especially I dedicate this book to all of the Eden Prairieites who helped me with their family information and pictures.*

# CONTENTS

Acknowledgments                                      6

Introduction                                         7

1.   Minnesota Native Americans                      9

2.   Pioneer Eden Prairie                            15

3.   Eden Prairie Families and Homes                 21

4.   Churches and Cemeteries                         59

5.   Schools                                         69

6.   Stores and Post Offices                         85

7.   Sites and Landmarks                             91

8.   Organizations and Ball Teams                    103

9.   Government and New Development                  111

10.  City-Owned Properties                           121

# ACKNOWLEDGMENTS

In 1989, I became president of our local Eden Prairie Historical Society. One of my first tasks was to microfiche all of our historical records for the City of Eden Prairie.

Our history room was located in the old City Hall, which housed our Senior Center. When I was there to do the microfiche, my friends from the senior group would stop in to say hello and look at our collection of pictures. The "I remember that" conversations were so prevalent that I thought it would be a good idea to get these photos all together in a book. Hence, the beginning of this endeavor.

Many more pictures and stories were needed, so I set out calling families, writing to them, visiting them, recording their stories, and collecting their old pictures. Special thanks to all of the families who helped me with their pictures and who gave me so much information. Special thanks also go to the many former residents who wrote to me sending their stories and pictures.

Others contributions to the book were made by:

<div align="center">

*Eden Prairie—The First 100 Years* by Helen H. Anderson

*History of Hennepin County* by R.J. Baldwin and Rev. Edward D. Neill

Eden Prairie Historical Society, articles on file

*Eden Prairie News*, articles and pictures

*Hennepin County Review*

*Hopkins Shopper*

Arthur Miller, interviews

*Minneapolis Star & Tribune*

Minnesota Historical Society

*Minnetonka-Eden Prairie Sun*

Dotty D. Nye, writings

*Old Rail Fence Corners*

*Prairie Register*

Sailor

*Star-Tribune*

*The History of the Diocese of Minnesota: Fifty Years of Church Work in Minnesota* by Rev. George C. Tanner D.D.

Marcia Ward, drawings

</div>

# INTRODUCTION

Eden Prairie got its name from Mrs. Elizabeth Fry Ellet, an authoress who came to St. Paul. On a trip up the Minnesota River, she climbed the river bluff to see the prairie in bloom. Mrs. Ellet was sure this area was as gorgeous as the Garden of Eden, hence the name Eden Prairie. Two wonderful books were published as a result of this visit: *Pioneer Women of the West* (1852) and *Summer Rambles in the West* (1853).

In the 1850s, fertile land west of the Mississippi River was open for settlers to claim. The early settlers had to endure poverty and the elements in the wilderness but became good friends and helped each other with the many jobs that required more than one man.

Listed here are some of the first families to come to Eden Prairie in the early 1850s: (from Ireland) Anderson, Brown, Mitchell, Gamble, Clark, Steenson, Hill, O'Connell, McCoy, Lucas, Neill, Moran, Morley, Glen, Ritchie, and Riley; (from the eastern states) Collins, Paine, Cummins, Staring, Curle, Tirrell, Bryant, Cornwell, Smith, Jarrett, Rankins, Hulbert, Goodrich, Pemberton, Gould, Raguet, and Hankins; (from Germany) Sieler, Rosue, Lenzen, Miller, and Pauly. Settlers in northern Eden Prairie were from Bohemia and came to join their friends and relatives in the Minnetonka-Hopkins area. Some of their names were Bren, Picha, Kucher, Dvorak, and Holasek. Nearly everyone in Eden Prairie was a farmer at this time.

The best incentive for immigrants to come to America probably came in the form of letters from those who had been here. These letters provided the American dream to the poor. In America, any family could have a home of their own and become landowners. This was not the case in the old countries.

The Pre-emption Act of 1841 enabled settlers to obtain land by settling on it and improving it so that they could later purchase it for $1.25 per acre when it was surveyed and offered for public sale. By 1855, all of the land in Eden Prairie was pre-empted.

Previous to state organization in 1854, under the territorial government, Hiram Abbott was appointed justice of the peace and William O. Collins was constable. These were the only offices held before the town was organized.

The township was organized in 1858, and the first town meeting was held on May 11th of that year in the old school house. This was the same day that Minnesota became a state.

The town of Hennepin came to be when John McKenzie made a claim in the southern part of the town near the river, on sections 34 and 35, in 1852. This was on the Minnesota River and was a platted village that included a hotel, store, and a few residences. It was at one time the chief shipping point for grain. However, it failed to flourish and was abandoned.

There were two major tribes of Minnesota Indians: the Sioux (or Dakota) and the Chippewa

(or Ojibway). By 1800, after years of bloody warfare, the Sioux had given up all of their land east of the Mississippi River and north or the Crow Wing River to the Chippewa. The two tribes remained traditional enemies even after the arrival of white settlers. They often had serious battles and continued to fight as late as the 1860s, when most of the Sioux were removed from Minnesota after the Sioux Uprising of 1862. On May 25, 1858, only a few days subsequent to the organization of the town, a violent Indian battle was fought between the Sioux and the Chippewa near Murphy's Ferry in the southern part of the town. It is now known as the Battle of Shakopee. The Chippewa numbered about 200 and the Sioux about 60 or 70. The Sioux, though inferior in numbers, fought with characteristic vigor and desperation and completely routed the Chippewa. This was the last battle ever waged between these two savage nations. Here, on the soil of Eden Prairie, the feud of centuries was terminated. Four years later, in 1862, the terrible Sioux outbreak against the whites occurred, which resulted in sending the remnants of the fierce Dakota (Sioux) bands to the Missouri Valley and plains of the far west.

In the mid-1800s, Eden Prairie had four schools and four stores, one in each corner of Eden Prairie. There was the Anderson School located where the Eden Prairie Center is now located; the Gould School located at the intersection of Eden Prairie Road and County Road No. 1, or Pioneer Trail; the Wolf School and the Tuckey Store, both located near Pax Christi Church; the Rowland Store in the northeastern part of Eden Prairie; and the Jarrett School, located near the Lil' Red Grocery.

For nearly 100 years, there were only two churches in Eden Prairie—the Methodist and the Presbyterian. Now there are over 20 churches.

Developers came in the 1960s and increased the population of Eden Prairie drastically. Eden Prairie has come a long way.

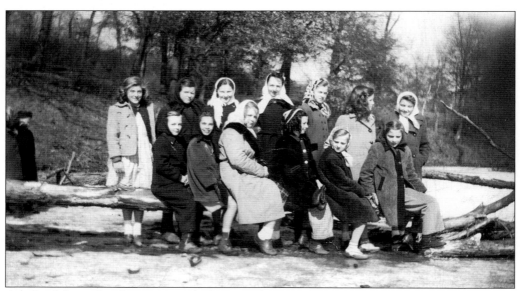

At school during lunch time, several of us went down to the bottom of the hill where there was a lake—we skated in our shoes on the frozen ice. This picture was taken when I was in grade school.

# One

# MINNESOTA NATIVE AMERICANS

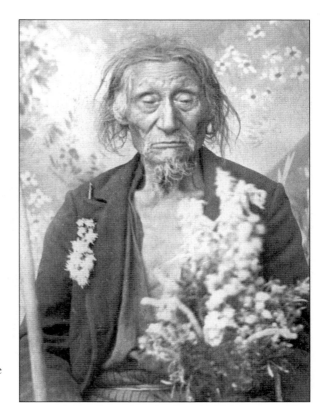

**CHIEF SHOTO.** Around the year 1800, John Shoto was born at Wabasha and remained with the band of Wabasha until he was 25 years of age. Then he went to join the Red Wing band of Sioux and served as their chief for 15 years. When Shoto left Red Wing, he came up the river and was chief of the Little Six band until the outbreak against the whites in 1862. Then he became a scout under Governor Sibley and served from 1862–1870. He returned to Shakopee in 1872 as chief of the Little Six band once more. Chief Shoto died in January of 1899, at the age of 99, at his home in the Indian settlement in Eden Prairie.

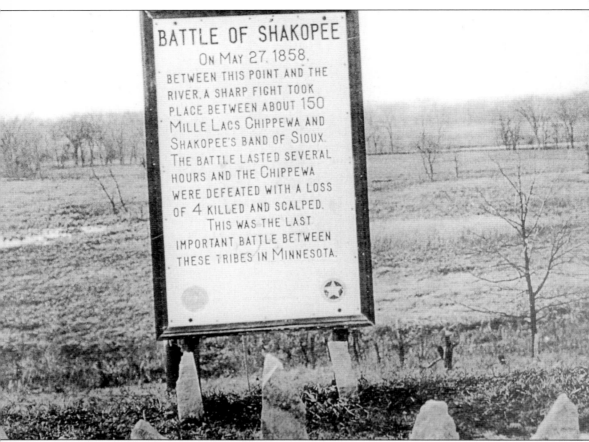

**SITE OF THE BATTLE OF SHAKOPEE, MAY 27, 1858.** "This was the last battle ever waged between these two savage nations. Here, on the soil of Eden Prairie, was terminated the feud of centuries. Four years afterward (1862), occurred the terrible Sioux outbreak against the whites, which resulted in sending the remnants of the fierce Dakota (Sioux) bands to the Missouri Valley and the plains of the far west . . . The warfare of these two aboriginal clans of warriors ceased forever."

—from *History of Minneapolis, also Hennepin County* (1895), Judge Isaac Atwater and John H. Stevens

There were two major tribes of Minnesota Native Americans—the Sioux (or Dakota) and the Chippewa (or Ojibway). When the explorers arrived here, the land was primarily settled by the Sioux, who were a primitive people depending on spears and bows and arrows to kill animals for food and clothing. The Chippewa came next from the Great Lakes area. They soon drove the Sioux out of the northern lakes and forests with the white man's guns, steel knives, and tools. In 1800, after years of fierce fighting, the Sioux surrendered their land east of the Mississippi River and north of the Crow Wing River to the Chippewa.

Even after the arrival of the white settlers, the two tribes remained enemies. They continued to fight as late as the 1860s, when most of the Sioux were removed from Minnesota after the Sioux Uprising of 1862.

On May 27, 1858, only a few days subsequent to the organization of the town, a fearful Indian battle was fought, which was witnessed by several of the settlers. It took place between the old enemies, the Sioux and the Chippewa, near Murphy's Ferry in the southern part of town.

The Chippewa wished to avenge a murder committed by the Sioux the previous fall near Crow Wing. To execute their plan, the Chippewa formed an ambush among the hills on the north side of the ferry. The Sioux were encamped on the south side. The Chippewa numbered about 200 warriors, the Sioux only about 60 or 70. The Chippewa, therefore, counted on an easy victory.

The contest began at early dawn with a detachment of Chippewa firing upon a fishing party of Sioux, who had unsuspectingly crossed to the north side. This roused the Sioux camp, and they took possession of the ferry promptly to cross and come upon the Chippewa at the banks of Big Creek; they established themselves in the vicinity of their enemy before they could be repelled. The Chippewa, finding their ambush a failure, made several attempts to dislodge their foes by strong detachments, but without success. The Sioux, though inferior in numbers, fought with characteristic vigor and desperation, and about one o'clock in the morning completely routed the Chippewa. The number is not known, but Noonday, a young chief of the Chippewa, fell and his body was horribly mutilated by Wau-ma-nuag, Chief of the Sioux.

Phillip Collins, who was an eyewitness, states that the Sioux Chief cut the heart from the fallen foe and drank of its blood, then after taking the scalp, cut off the head and carried it on a pole to the Sioux camp near Shakopee. Then the victory was celebrated by a scalp dance, lasting several days, characterized by their usual barbarities. The body of the young chief was burned.

After the fight, Mr. Collins found in a pouch containing the pipe, kinnickinnick, etc. of a fallen Chippewa, a crude map on birch bark, which bore, besides the localities of hills, lakes, and rivers of that vicinity, several mysterious characters, among them figures representing cows, foxes, etc. It is unfortunate that this relic was lost.

—from *History of Hennepin County and the City of Minneapolis, Including the Explorers and Pioneers of Minnesota* (1881), Rev. Edward D. Neill

We made our home on the south side of Red Rock Lake near an Indian campground. One of our rarest relics is a pipe-stone pipe which lay in the ground for over seventy years according to the judgments of the oldest settlers and probably was the property of Chief Red Rock whose grave was located on our farm. Indians came every year to mourn the death of their chief and each year painted red a large rock which marked his grave. The body of this Sioux chieftain was moved to the area of Birch Island Lake north of Glen Lake about 1890 after the historic red rock had been stolen from our farm.

—James Stewart, *Hennepin County Review*, November 7, 1929

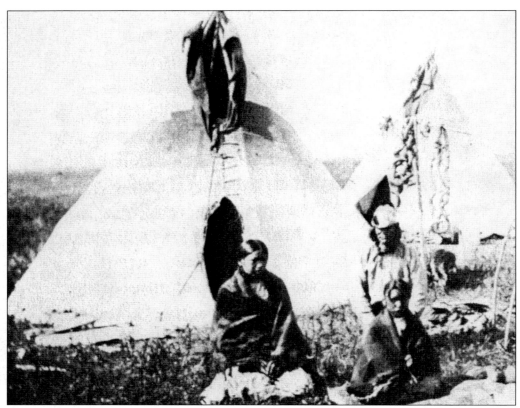

**SIOUX TEPEES.** Sioux tepees were cone-shaped structures with skins stretched over a framework of poles. This Minnesota Historical Society photograph dates to *c.* 1900.

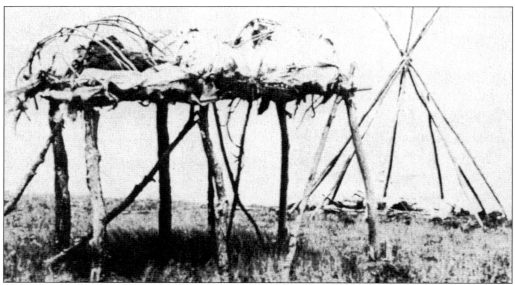

**BURIALS ON POLES.** This *c.* 1870 photograph of traditional burial scaffolds was taken by D.F. Barry and belongs to the Minnesota Historical Society.

**RED ROCK, THE SACRED PAINTED BOULDER AT RED ROCK LAKE.** There was a red rock sacred to the Sioux Indians on the western shore of Red Rock Lake. Indians used to sit in council around this rock before and after their battles. They also gathered there every year to mourn the death of their Chief Red Rock. The red rock was stolen around 1890, and the body of Chief Red Rock was then moved to Birch Island Lake north of Glen Lake.

We lived about four miles from Shakopee, at what was called Eden Prairie. My father was William O. Collins. The Sioux Indians' old camping ground and home was on the river bottoms at Shakopee. Three miles below our place was Hennepin Landing, where the boats landed coming from St. Paul. The trail of the Sioux led directly past our house, so we saw a great deal of the Indians. (*Note: This property is on Pioneer Trail across from the airport where Ron and Kathie Case now live.*)

One thing we were taught was to never show fear of the Indians. They knew very quickly and loved to scare anyone who showed they were afraid. Chaska and five of his men had been out duck hunting and stopped at our home for supper the night before the outbreak of 1862. The Indians were always friendly with all members of my father's family and never asked for a meal unless they were willing to pay with ducks or in some way. The next morning after Chaska had supper with us, a man came riding from St. Peter telling everyone to flee. Twenty families (ours among the others) remained.

One day on my way to school, I heard the children calling me to run, but the grass was so high I could see no one and did not know an Indian was near. When I saw him, I was not afraid. I went to the schoolhouse door, but the teacher was so frightened she had locked the door, and I could not get in. I stood waiting and the Indian patted me on the head and said, "Heap brave papoose" and went down the trail.

—Mrs. Frederick Penny, *Old Rail Fence Corners*

My father, Oliver Faribault, built a house which was his home and trading post near "Little Six" of Shakopee's village in 1844. It was a fine point for a trading post, as three Indian villages were near: Good Road's, Black Dog's, and Shakopee's. He was a very successful trader. I can well remember the great packs of fur. We used to play all around the country near the post. I could shoot an arrow as well as a boy. (Note: This cabin is presently at Murphy's Landing in Shakopee.)

We used to go often to the sacred stone of the Indians and I have often seen the Sioux warriors around it. There was room for one to lie down by it and the rest would dance or sit in council around it. They always went to it before going into battle. They left gifts which the white people stole. I can remember taking a little thing from it myself. I passed a party of Indians with it in my hand. One of the squaws saw what I had and became very angry. She made me take it back. She seemed to feel as we would if our church had been violated. This stone was stolen by a man from the East and taken there. This loss made the Indians very angry. (Note: This stone was west of Red Rock Lake.)

The Indians did not understand the white man's ways. When the white man had a big storehouse full of goods belonging to the Indians and the Indians were cold and hungry, they could not see why they could not have what was belonging to them if it would keep them warm and feed them. They could not see why they should wait until the government told them it was time for them to eat and be warm. It was the deferred payments that caused the outbreaks. This is what I often heard from the Indians.

One morning in the summer of 1858 we heard firing on the river. Most of the Sioux had gone to get their annuities but a few who were late were camped near Murphy's Ferry. These had been attacked by a large band of Chippewa. The fighting went on for hours, but the Chippewa were repulsed. That was the last battle between the Sioux and Chippewa near here.

I have often seen Indians buried on platforms elevated about eight feet on slender poles. They used to put offerings in the trees to the Great Spirit and also to keep the evil spirits away. I remember that one of these looked like a gaily colored umbrella at a distance. I never dared go near.

—Miss Sara Faribault, *Old Rail Fence Corners*

When we first came to live in Eden Prairie I thought I had never seen anything as beautiful as that flowering prairie. In the morning we could hear the clear call of the prairie chickens. I used to love to hear it. There were great flocks of them and millions of passenger pigeons. Their call of "Pigie! Pigie!" was very companionable on that lonely prairie. Sometimes when they were flying to roost they would darken the sun, there were so many of them. Geese and ducks were numerous, too. Blackbirds were so thick they were a menace to the growing crops. I used to shoot them when I was 12 years old.

We had a cow named Sarah. She was a lovely, gentle creature. Mr. Anderson brought her up on the boat. My dog was an imported English setter. These and an old pig were my only playmates. I used to dress my dog up, but when I found my old pig would let me tie my sunbonnet on her I much preferred her. She looked so comical with that bonnet, lying out full length and grunting little comfortable grunts when I would scratch her with a stick.

I never saw such a sad experience in the eye of any human being as I saw in Otherday, the Sioux friend of the whites. It seems as if he could look ahead and see what was to be the fate of his people. Yes, I have seen that expression once since. After the massacre, when the Indians were brought to Fort Snelling, I saw a young squaw, a beauty, standing in the door of her tepee with just the same look. It used to bring tears to my eyes to think of her.

There used to be a stone very sacred to the Indians on Alexander Gould's place near us. It was a red sandstone and set down in a hollow they had dug out. The Sioux owned it and never passed on the trail that led by it without squatting in a circle facing it, smoking their pipes. I have often stood near and watched them. I never heard them say a word. They always left tobacco, beads and pipes on it. The Indian trails were worn deep like cattle paths.

—Mrs. Mary Staring Smith, *Old Rail Fence Corners*

# *Two*
# PIONEER EDEN PRAIRIE

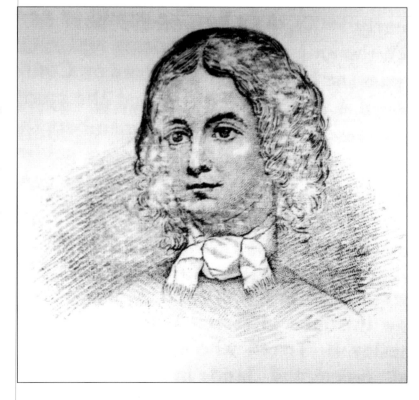

**ELIZABETH FRY ELLET.** Mrs. Ellet, an authoress, came to St. Paul from New York with a Miss Clark in 1853. They named several bays and points on Lake Minnetonka. On a trip up the Minnesota River, they climbed the river bluffs to see the prairie in bloom. Mrs. Ellet was sure the area was as gorgeous as the Garden of Eden and named the area Eden Prairie.

**EARLY ROAD IN EDEN PRAIRIE.** Eden Prairie is situated on the Minnesota River, which forms its entire southern boundary. It is bounded on the north by the city of Minnetonka, on the east, by Richfield and Bloomington and on the west, by Watertown in Carver County. The whole city is fertile, having a clay sub-soil. It was an agricultural area, adapted to all varieties of grain, corn, vegetables, and grass. In early days, the prairie was the greatest producer of wheat of any part of the country. Later it was a large producer of farm products. The northern part consists of considerable timber.

It has many lakes and some marshes. The lakes are characterized by the usual gravelly shores and high banks that make the lakes of the country so beautiful. It is watered by many small streams. The largest, Mill Creek, begins in Minnetonka and flows across the city from north to south, through Staring Lake, and empties into the Minnesota River.

Eden Prairie was first settled in 1851, by John McKenzie, David Livingston, Alexander Gould, Hiram Abbott, R. Neill, Aaron Gould, Samuel Mitchell Sr. and his sons, and others. Mr. Abbott made the first claim on the north part of the prairie in 1851. This is adjoining the city-owned Cummins-Phipps-Grill property near what is now Flying Cloud Airport.

The township was organized in 1858, and the first Eden Prairie town meeting was held on May 11th, 1858 in the old school house. That was the same day that Minnesota became a state. The following officers were elected: Supervisors Aaron Gould (Chairman), Robert Anderson, and William O. Collins; Clerk William H. Rouse; Collector A.K. Miller; Assessor William J. Jarrett; Overseer of Poor John Keeley; Justices William O. Collins and James Gamble; and Constables A.K. Miller and Arch. Anderson. The total expense of the town for the first year was $55.04.

The town officers for 1880 were: Supervisors William Hulbert (Chairman), William Anderson, and Aaron S. Neill; Clerk William O. Collins; Assessor George N. Gibbs; and Treasurer Sheldon Smith. The population recorded for the 1880 census was 749.

The first marriage in Eden Prairie was held between William Chambers and Martha Mitchell in the winter of 1852–1853. The first white woman to live in the town was Jane Mitchell, who became the wife of Frank Warner, of Carver. She came in 1852 to keep house for her father and brothers before the other members of the family arrived. The farm where they lived is now owned by the heirs of Fred Miller.

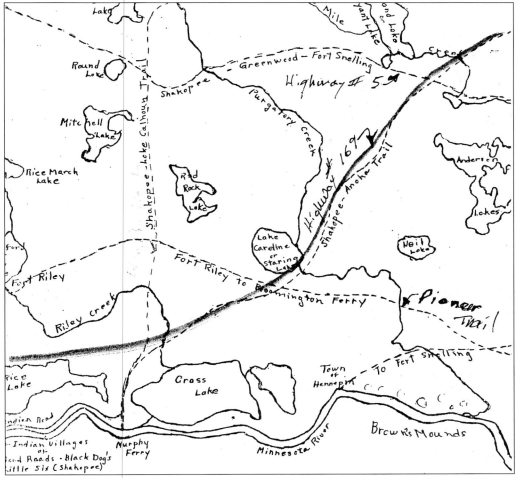

Map showing lakes, streams, trails, and landmarks including Round Lake, Mitchell Lake, Rice Marsh Lake, Red Rock Lake, Lake Caroline or Staring Lake, Neill Lake, Anderson Lakes, Grass Lake, Rice Lake, Fort Riley, Minnesota River, Browns Mounds, and various trails including Greenwood – Fort Snelling, Highway #5, Highway #169, Shakopee–Anoka Trail, Shakopee–Lake Calhoun Trail, Fort Riley to Bloomington Ferry, Pioneer Trail, and To Fort Snelling. Indian Villages and Roads – Black Dog's, Little Six (Shakopee), Murphy Ferry, Town of Hennepin.

**LAKES AND STREAMS.** The lakes in Eden Prairie were named after the pioneer families who lived near them. Anderson Lakes were named for Mrs. Robin Anderson and her family, who came from Ireland. Staring Lake was named after Jonas Staring's wife, Catherine, although it was also known as Goodrich Lake. Riley Lake was named for Irish settlers Patrick and Matthew O. Riley. Mitchell Lake was named for fellow Irish immigrant David Mitchell in 1852. Neill Lake was named for town founder Aaron Neill in 1850. Bryant's Long Lake was named for William V. Bryant in 1852, and was also known as Island Lake, because of the submerged island it contained, which was reportedly a good fishing spot. Red Rock Lake was the site of the famous red rock, sacred to the Sioux Indians, which was on the lake's western shore. The Indians also had a camp among the birch trees beside Birch Island Lake. Grass Lake was earlier called Tirrell Lake, after Judge Chelsey B. Tirrell from Maine. Rice Lake was where Indians gathered wild rice.

Creeks were also named by early residents of Eden Prairie. Mill Creek was close to the grist mill in central Eden Prairie. Hennepin Creek was near the town of Hennepin. Purgatory Creek was known by three different names in the areas it flowed through; the old Shakopee Road crossed the creek in Bloomington and early French settlers called it Nine Mile Creek as it was nine miles from Fort Snelling to this crossing. Mrs. Anna Simons Apgar recalled in 1854 that when her family and five other pioneer families came upon the swampy land close to Purgatory Creek, one of the tired men said, "This is Hell!" "No" said another, "Purgatory."

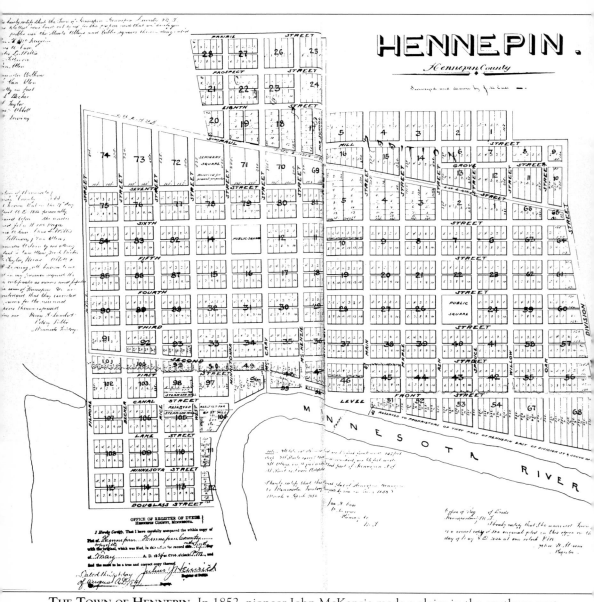

**THE TOWN OF HENNEPIN.** In 1852, pioneer John McKenzie made a claim in the southern part of the town near the river on sections 34 and 35. In company with Honorable Alexander Wilkin, the secretary of the territory, and others, he platted a village and called it Hennepin. It was located right on the Minnesota River. A hotel, a store, and a few residences were built. It was, at one time, the chief shipping point for grain, which was taken in the small steamers that plied up and down the Minnesota River. Like many a projected city of the west, it failed to flourish and was abandoned.

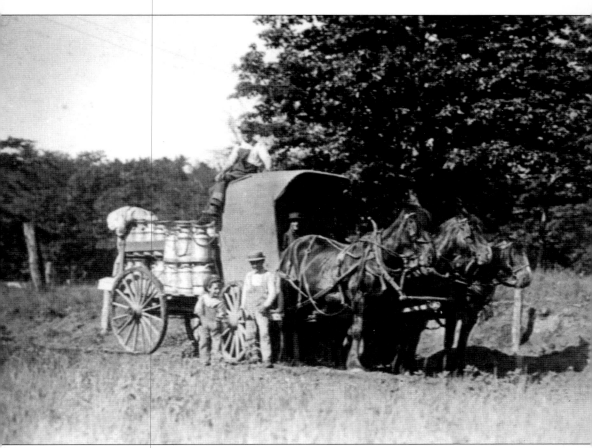

**DAN BLAKEBOROUGH MILK WAGON.** This picture of Dan Blakeborough's milk wagon, complete with canisters of milk in the back and a team of three horses in front, was taken in the early 1900s.

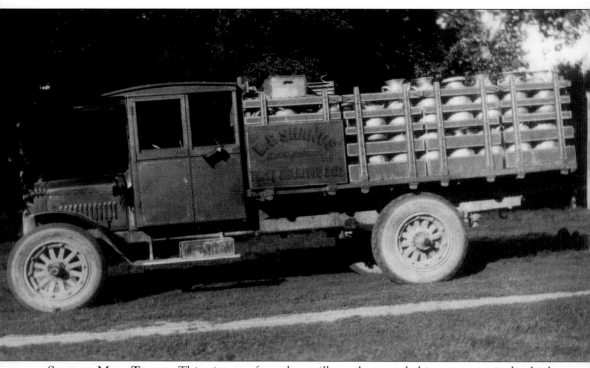

**SHANUS MILK TRUCK.** This picture of another milk truck, upgraded into a motorized vehicle with fencing securing its cargo, was probably taken slightly later in the 1900s.

# *Three*
# EDEN PRAIRIE
# FAMILIES AND HOMES

**JOSIAH OOTHOUDT HOME.** This home was built in 1881, and burned down around 1908. Josiah P. Oothoudt's family came from the Netherlands in the 1600s; he was born in New York in 1822. In 1880, Josiah purchased land west of the Interchange of Highways 5, 169, and 494 in Eden Prairie from George H. Rust and moved there with his family.

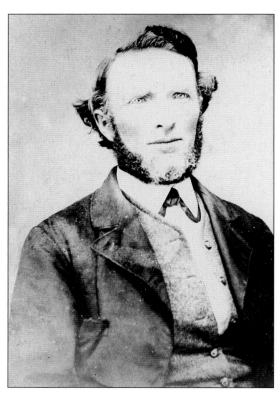

**ALEXANDER MITCHELL SR. AND SARA DEAN MITCHELL.** Alexander Mitchell Sr. was the son of Eden Prairie pioneer David Mitchell, who came from Ireland in 1853.

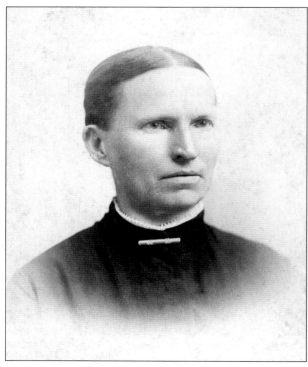

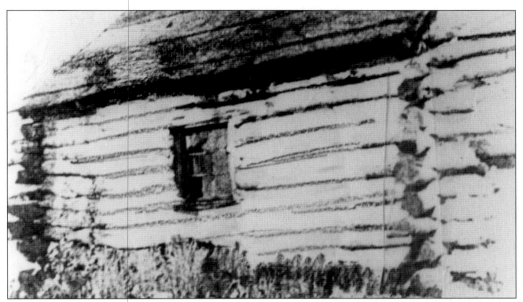

**DAVID MITCHELL'S LOG CABIN ON MITCHELL LAKE.** Samuel Mitchell was one of the first settlers of Eden Prairie in 1852. David Mitchell came with his family from Monaghan County, near Belfast, Northern Ireland, in 1853. In addition to David's wife, Elizabeth Thompson Mitchell, there were seven children: John, Martha, Andrew, Samuel, Alexander Sr., Rachel, and Jane. David's parents were from Scotland. David's brothers and sisters were: James, Archibald, Martha, Frances, Jane, Elizabeth, John, Andrew, and Samuel. His sister, Martha, married William Chambers, who ran the Bloomington ferry. Theirs was the first marriage in Eden Prairie.

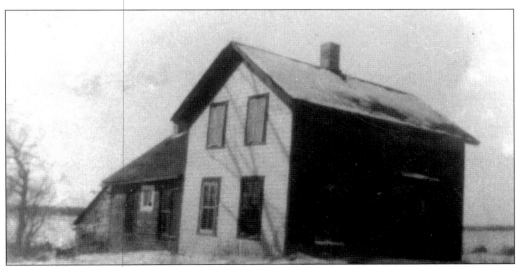

**ALEXANDER MITCHELL SR. HOME ON MITCHELL LAKE.** Mitchell Lake was named for the family of David Mitchell and was the site of their home as well as the homes of some of their descendants.

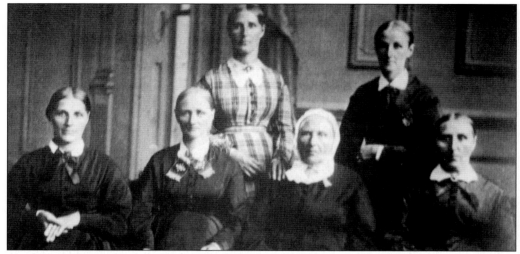

**ANDERSON WOMEN.** Pictured from left to right are the women of the Anderson family: (front row) Ann Jane Brown, Sarah Gamble, Elizabeth Anderson, and Martha Ritchie; (back row) Fannie Mitchell and Bessie MacCaraigue. James Anderson of Sixmilecross, Ireland, had two sons: Robert (who was called Robin) and William. Robin was the oldest. He married and had two sons, Robert and James. Robin's son Robert married Elizabeth Mitchell and had 15 children. As times were hard in Ireland due to the potato famine, young people looked to America for a future.

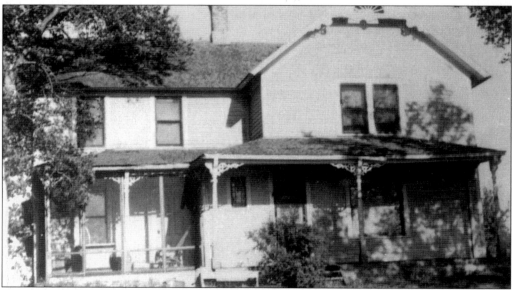

**ELIZABETH AND WILLIAM ANDERSON FARMHOUSE IN EDEN PRAIRIE.** Robert was the first of the Robin and Elizabeth Anderson family to leave home. He married Mary Jane Hill and they left for America, arriving in Galena, Illinois, where they had relatives. Most of the good land had been taken in Galena, so they went to Eden Prairie, Minnesota, and staked out two claims, one for themselves and the other for his brother, James. When Robert's father died, his mother sold the family mills in County Caven and left for America with the rest of the family. Three of her children remained in Galena while the rest came to Eden Prairie. The Andersons had large families, and farms were passed from father to son.

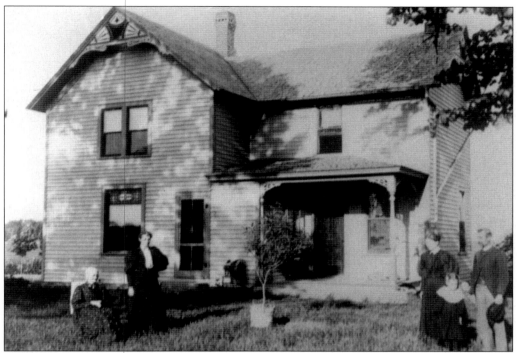

CORNWELL-GAMBLE FARMHOUSE. James Gamble was one of the earliest settlers in Eden Prairie and was married to Sarah Anderson, sister to many other Andersons who settled in Eden Prairie. James taught the "three R's" to neighborhood boys and girls in the sitting room of his log cabin, which also served as a school. Their farm extended from Hwy. 5 across Idlewild Lake and along the west side of Eden Road to what is now Flying Cloud Drive.

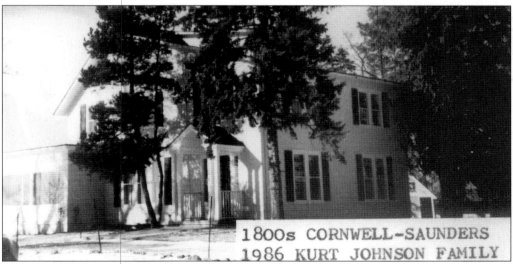

CORNWELL-SAUNDERS-JOHNSON HOME. This historic homestead, which dates back to the 1800s, once served as a home to vice president and former mayor of Minneapolis, Hubert Humphrey and his family. It is located on Anderson Lakes Parkway. In 1986, it became the Kurt and Margaret Johnson Home.

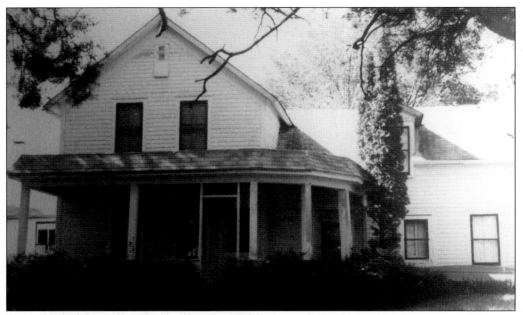

**SAMUEL AND JAMES ANDERSON HOME.** This homestead was located at the corner of Pioneer Trail and the old County Road 18.

**SAMUEL ANDERSON.** This homesteader helped to establish eastern Eden Prairie and the Anderson Lakes area. He lived from 1834 to 1928.

**JAMES ANDERSON.** James' brother Robert Anderson staked out a claim for him upon arrival in Eden Prairie.

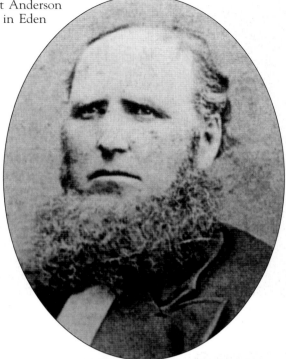

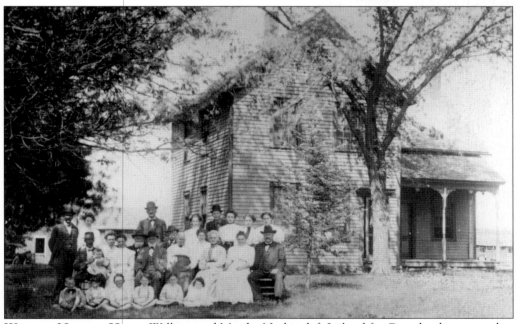

**WILLIAM NESBITT HOME.** William and Martha Nesbitt left Ireland for Canada, then moved to Bush Lake, and eventually came to Eden Prairie. They settled on the original 200-acre homestead of Robert Anderson. This farm, located north of Anderson Lakes Parkway, is now part of the Preserve.

27

**WILLIAM AND MARTHA NESBITT.** William and Martha Nesbitt's son, William Walter, married Ellen Jane Glenn and were the parents of ten children: George, Walter, Irene, Henry, Arthur, Ralph, Stanley, Everett, Hazel, and John. Ralph, his wife, Marian, his brother, Stanley, and Stanley's wife, Irene, sold part of their farm to the Preserve in the early 1970s and built houses there.

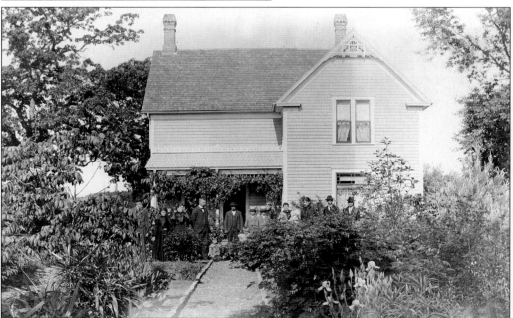

**MORAN HOMESTEAD ON HWY. 5.** George N. Moran was the eldest child of the family and was an Ulster-Scot. He arrived in Minnesota in 1854. He took a homestead on the west side of Mitchell Lake; then brought his parents, brothers, and sisters here. George N. married Eliz Detweiler, and they were the parents of Alice Niblett, Edwin, Ida Mann, Hattie Bear, William, and James. All were born in the house he built beside the lake. William was married to Mary Giesler. They had five daughters: Mabel, Hazel, Ida, Evelyn (Rogers), and Lucille.

**JAMES W. AND ALICE GAY WHITE MORAN.** James W. Moran, the son of George N. Moran, married Alice Gay White, and they became the parents of three boys: George W., Everett L., and James Elmer.

**GEORGE W. AND MABEL TOBIAS MORAN.** George W. Moran, the son of James W. Moran, married Mabel Tobias. They had three children: Carolyn, George M., and Wallace.

**EVERETT L. AND IRENE STARING MORAN.**
Everett Moran was the son of James W.
and the brother of George W. and James
Elmer Moran. He married Irene Staring,
and they became the parents of two
children: Lyle and Joyce.

**JAMES ELMER AND ELLA REDNER MORAN.**
James Elmer (known as Elmer) married Ella
Redner, and they became the parents of
seven children: Beulah, James, Arlene,
Robert, Judy, Sandy, and Russell.

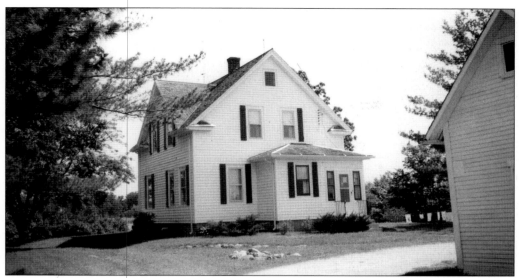

**PICHA HOME, 6649 BIRCH ISLAND ROAD.** Frank Picha came to America from Czechoslovakia. He and his wife, Anne (Makousky), settled in Minnetonka. They were the parents of five children: Frank, George, Joseph, Mary, and Anne. Frank raised 8,000 bushels of wheat one year, which sold at $1 per bushel. This enabled him to buy enough land to give 80 acres to each of his children. Albert and Harry are the children of George and Minnie Picha. They lived in Minnetonka until Albert was one year old, then they moved to Eden Prairie at 6649 Birch Island Road where Harry and his wife, Adeline, resided.

**6525 BIRCH ISLAND ROAD.** Albert Picha married Abbie Tuckey and moved into the former Manchester homestead located next door to Harry Picha at 6525 Birch Island Road. They engaged in dairy farming, but their main interest was in raising acres and acres of tomatoes and berries. They also had some fruit trees and thousands of tomato plants.

**HULBERT FARM LOCATED ON EDEN PRAIRIE ROAD.** Charles E. Hulbert was born in 1864 in Pittsfield, Michigan, as was his father, William Frank, in 1837. His mother, Rachel Booth Hulbert, was born in 1844 at Lodi, Michigan.

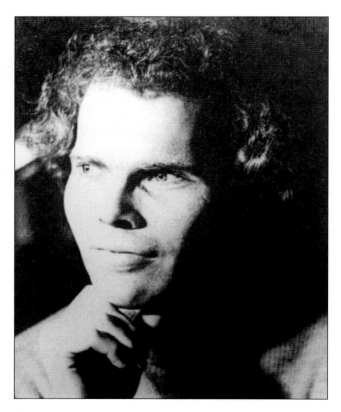

**DUANE HULBERT.** The great-grandson of Charles and Losetta Goodrich, Duane Hulbert was an accomplished musician, earning both Bachelors and Masters degrees at Julliard. He was winner of the Julliard Concerto Competition in 1978. Of this, a journalist writing for the *New York Daily News* reported " . . . the best performance of this concerto I have ever heard. I wish that the composer had been there to hear it."

**EDWARD AND CAROLINE OLESON GOOD.** Edward Good came from New Brunswick, Canada, to Eden Prairie. He married Caroline Oleson, and they became the parents of six children: Verna, Chester, Howard, Marvin, George, and Gladys.

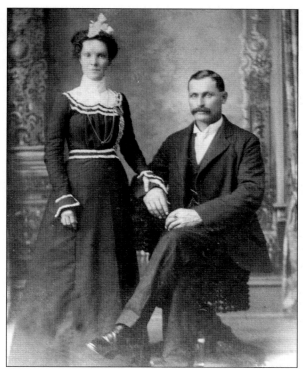

**GOOD HOME LOCATED ON PIONEER TRAIL.** The Goods lived on what is now 18600 Pioneer Trail in a red brick house on a five- to six-acre berry farm. Caroline contracted the dreaded flu of that time and passed away in 1918, leaving the six young children. Edward was a carpenter by trade and is credited with building many houses and other buildings in that era.

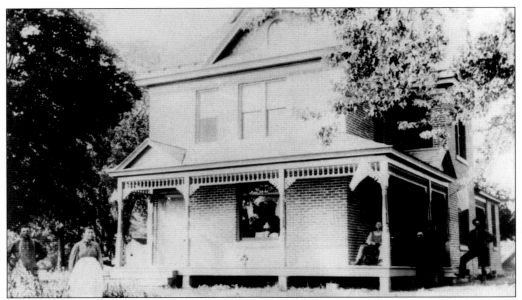

**BRUM HOME C. 1896.** John H. Brum was born in Michelburg Schwerin, Germany, in 1811. In 1843, he married Dorothea Bolle. In the spring of 1853, he came to Minnesota with his wife and three children: William, Mary, and John. In Chanhassen Township he homesteaded in the northeast quarter of Section 25. The family probably settled in Chanhassen because the people there also spoke the German language. There was no bridge over the Minnesota River to Shakopee in 1854, only the Murphy Ferry, which would charge each person who crossed it. This is probably why they did their business in Chaska and also attended the Moravian Church there, as the services were spoken in German.

**ORIGINAL LOG CABIN BUILT BY CHARLES REES C. 1858.** Pottery was made by Charles Rees on his farm, Elmwood, which was on Purgatory Creek where the Brum home was located on Research Road. This later became the headquarters for Northrup King and is presently the site of Oak Point School. Stoneware containers were used for making sauerkraut and storing molasses, cookies, butter, milk, and staples as well as flower pots. Red bricks were also made here.

**DR. ROBERT MORRIS PAGE.** Clarence Q. Page and Lily Wintermute Page lived in the house on Homeward Hills Road that had been part of the old Wolf school. The house was no longer needed for school use after the consolidated school was built. Their son, Robert Morris, entered the University with plans to go into the ministry as his father had. A professor recognized his scientific ability and encouraged him towards physics. He went on to build the country's first pulse radar system. He holds more than 60 patents in the field of radar and was honored by three United States presidents.

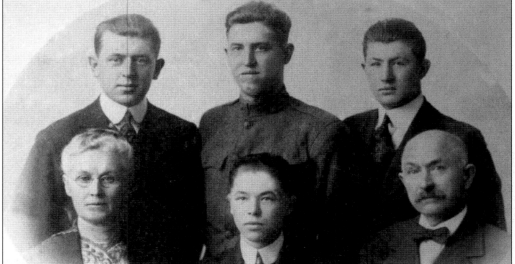

**FRED F. MILLER FAMILY.** Miller family members are pictured here from left to right as follows: (front row) Katherine, Norman, and Fred F.; (back row) Fred Jr., Arthur and Harold. In 1850, the Millers came to Eden Prairie and settled on a farm located northwest of Hwy. 5 and Eden Prairie Road, where the Prairie Village Mall is located today. The name Miller was spelled Muller in Germany. The name Frederick spans five generations in the Miller family. Arthur Miller's grandpa, Fred Miller, was married in Chicago to Charlotte Mathies. He came to Minnesota and bought a farm southwest of Riley Lake. His grandpa then bought a farm west of Chanhassen on County Road 41 and Hwy. 5. This was later sold, and he bought the Samuel Mitchell farm. Arthur's dad stayed on this farm with his mother and sisters until he was 19 years old. He then started on his own and bought the Rankin store north of the railroad tracks on Eden Prairie Road. The Rankin store was the location of the Washburn post office. Mr. Rankin was the postmaster. Arthur's dad took his brother, John, into the business. They bought the land south of the tracks from the Rankins and had Jim Clark build a store and house. This store, their house, and grandmother Miller's house burned in a fire on December 5, 1963. Arthur's dad married Katherine Lenzen, his brother married Mary Lenzen, and Henry Pauly married Christine Lenzen.

**PAULY HOME LOCATED ON HWY. 5.** Nick Pauly, grandfather of Emil, and his three brothers came from Luxembourg to this area in 1850. Nick Pauly settled near Lake Susan, south of Chanhassen. At that time Hwy. 101 was the old Indian trail from Shakopee. Henry Pauly was born in 1855 and was the first white child to be born in Carver County. Henry married Christine Lenzen of Eden Prairie. He bought land next to the Lenzen place. It was there that Emil and his three brothers were born.

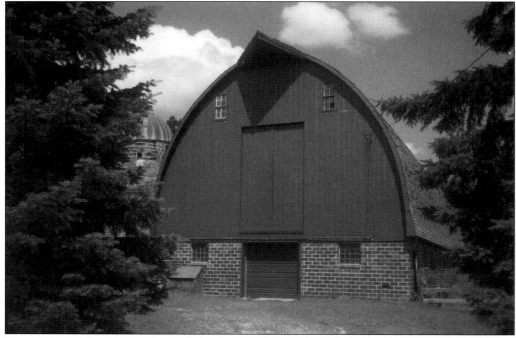

**PAULY BARN.** Emil later operated this farm. He raised his six children here, and his youngest son, Roger (married to State Representative Sidney Pauly), is now living at the same location.

**THE OHM HOMESTEAD**. Thomas Ohm was born in Germany in 1829 and lived with his parents until the age of 15. In 1848, he came to America, stopping in Milwaukee, then traveling to Galena, Illinois, and arriving in Minnesota in 1851. Thomas went to Carver County and then on to Eden Prairie. He married Mary Basler of Illinois in 1856. They were the parents of 11 children, including Charles, Mary A., Alfred, John, Mary M., and Anna.

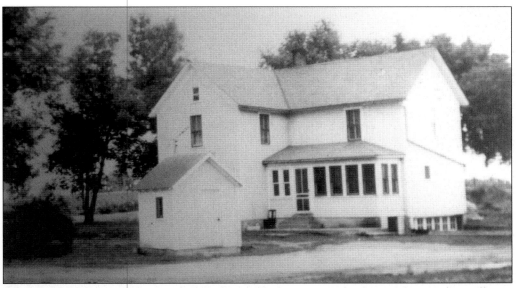

**THE SECK HOMESTEAD**. George and Catherine Seck came to Eden Prairie from Galena, Illinois via riverboat in 1879. They were of German ancestry and were the parents of six children: George, Frank, Charles, Roy, Walter, and Amanda. They made their home on the northeast shores of Duck Lake, homesteading 60 acres of land. Charles Ohm and Catherine Seck were cousins, and they stayed with the Ohm family while their house was being built. The house, along with the farm buildings, were demolished in 1985, making way for new development.

(*left*) **SEVERIN PETERSON**.
(*below*) **MARY PETERSON**. In 1886, Severin Peterson left Sweden to come to America. He stopped in Illinois, then moved on to Minneapolis. He married his wife, Mary Peterson (Inga Maria Harling) in 1896. They lived above their confectionary store. After twins Martha and Alice were born and they learned they were expecting a second set of twins in 1899, they decided it wasn't wise to live above the store with all those children. They bought 40 acres of land in Eden Prairie on Spring Road. Later they bought an additional 49 acres.

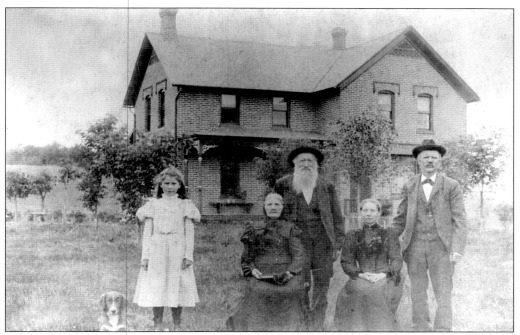

**KRUGER-BERGER-SABLE-ATKINS FARM.** John and Bertha Kruger were early settlers in Eden Prairie, residing at which is now 9580 Eden Prairie Road. This red brick house was built in 1864 and was remodeled (below) and stuccoed in the 1960s.

**ORIGINAL KRUGER FARM C. 1990.** After the Krugers, the house was occupied by the Rudy and Ada Mitchell Berger family from the 1920s through 1950s, then by Floyd and Jean Sable, and then the Don Atkins family.

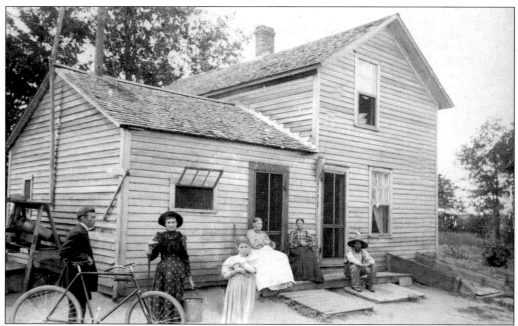

**REIMER-KRUGER-SOHM-KNUTSON-LINDAHL HOME.** This home was built by John Reimer on what is now 9850 Eden Prairie Road. Next it was the home of August Kruger, then the Louis Sohm family residence. Augusta Kruger, daughter of August, married Louie Sohm, who came from LeSueur, Minnesota. They were the parents of Lorraine, Donald, Dorothy, and Clifford.

**ORIGINAL REIMER HOME C. 1990.** The Harold and Norma Knutson family were owners of this home before building a new house on the adjoining lot. They were followed by Steve Lindahl, who has been doing extensive ongoing remodeling since he moved in.

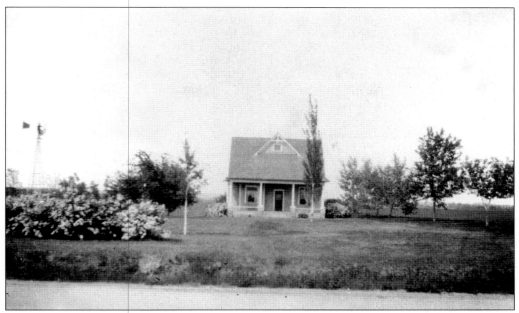

FRANCOIS LA RIVIER (FRANK RIVERS) HOMESTEAD. This property was pre-empted in the 1850s by Judge Charles Collins, who came from the east. The property was sold many times between 1855 and 1874. In 1874, Francois La Rivier, later known as Frank Rivers, purchased the farm.

LA RIVIER HOMESTEAD IN THE 20TH CENTURY. In 1921, John and Stella Laird purchased La Rivier's farm for use as rental property and painted all the buildings yellow. The farmstead became known as "the farm with the yellow buildings." Many fine Eden Prairie families rented the farm up until the 1990s, at which time it was purchased by Ron and Kathie Case who extensively remodeled it.

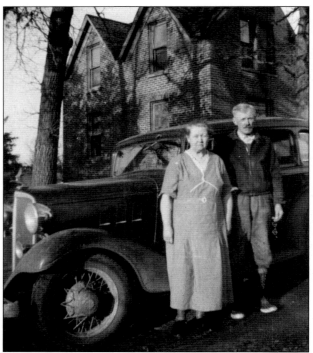

**LA RIVIER-OLIVER-ZELL FARM.** In 1903, Myron Oliver bought the farm in Eden Prairie located on Pioneer Trail west of Hwy. 169 from Frank Rivers. Julius Zell married Edith Oliver, and they went to live on this farm for most of their married life. Julius and Edith were the parents of seven children: Sidney (who married Lois Oothoudt), Harold, Merrill (who married Alice Rogers), Lyle, Forrest, Maurice, and Ruby.

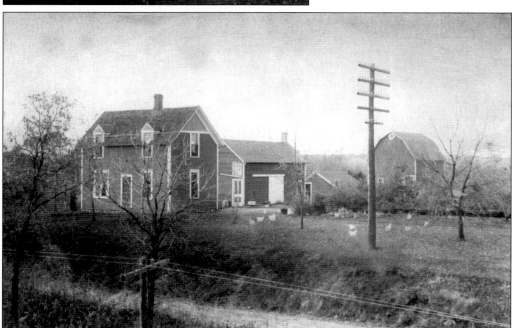

**HIGBIE HOMESTEAD LOCATED AT 8310 EDEN PRAIRIE ROAD.** Wilson Stanley Higbie and his wife, Lillie Belle Lindsley, came to Eden Prairie from Alden, Minnesota, in 1897 and settled on 50 acres of land purchased from Sam Mitchell and Fred Miller. They ran the Hennepin County Nursery during their stay in Eden Prairie. There were apple trees of all kinds, plum and cherry trees, strawberries, currants, raspberries, and gooseberries.

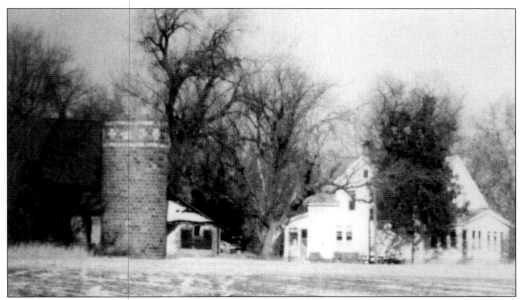

**PRESTON AND HOMER RAGUET HOME ON SPRING ROAD.** In 1860, Henry Wynkoop and Elizabeth Hallam Raguet came to Eden Prairie from Ohio to live on the farm on what is now Spring Road. They had nine children: Conde, Henry, Preston, Margaretta, George, Samuel, James, John, and Claudine. Henry was French and Elizabeth, English. Preston married Katherine Olson from near Jordan, Minnesota, in 1903. They had two children: Iona and Homer.

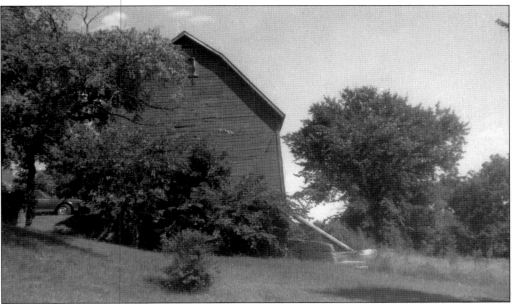

**HENRY RAGUET BARN ON RIVERVIEW ROAD.** Henry Raguet married Helena Brant and had two sons, Dave and John. Dave never married. John (Jack) married Alma Raddatz and had one daughter, Dorothy, who married Rolland Doughty and resided on Sunnybrook Road in Eden Prairie. Alma died during the flu epidemic in 1918. John later married Hilda Anderson and had another daughter, Joyce, who married Paul DeLecour.

**WILLIAM J. JARRETT.** William J. Jarrett was born in 1823 in Pennsylvania. In 1838, he moved to Allentown, where he farmed until 1840. He then went to Munch Chunk to work as courier, married Susan Detweiler and had six children. In 1857, Jarrett came to St. Anthony, where he worked with his brother in a hotel until it was destroyed by fire in 1873. He then came to Eden Prairie to farm on 320 acres.

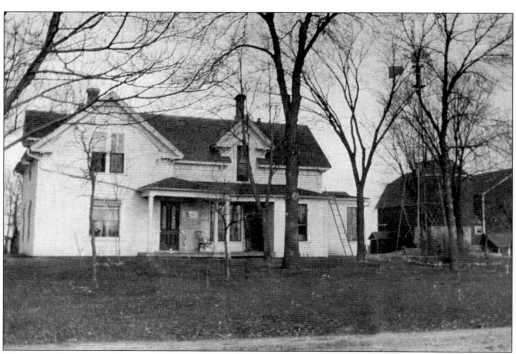

**WILLIAM JARRETT HOME ON EDEN PRAIRIE ROAD.** Jarrett's home was located near the Lil' Red Grocery.

**FRANK AND ANNA SCHWARTZ.** In the early 1900s, Jesse Schwartz's parents, Frank and Anna, lived in Bloomington Township in the Eden Prairie School District. Jesse married Irene Mills. They were schoolmates and neighbors. They had two children: Jesse Jr. (married to Kathy Robertson) and Jill, who is married to Jock Grier. Jesse and Irene became co-owners of the W. Gordon Smith Company in Eden Prairie (Flying Red Horse). In the 1930s and 1940s, Jesse was a pitcher for the Shakopee Indians and led them to the state championship. He was an outstanding pitcher and, as the old-timers say, could have made it big in the major leagues; but he preferred to stay in this area, which he loved.

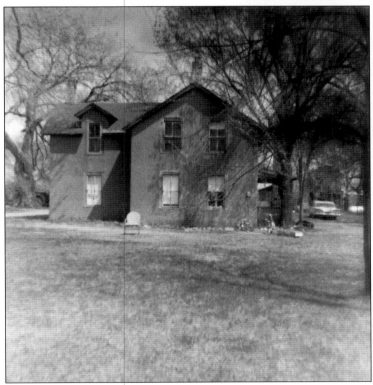

**GEORGE V. HANKINGS.** George Valentine Hankins' grandfather was a hatter by trade in New York. He had two sons, one of which was Alexander Barclay Hankins, father of the second Mrs. Charles Hulbert. He was born in 1846 at Newark, New Jersey. He came to St. Anthony in 1859, then on to Eden Prairie. In 1881, he married Jeanette EllenGoodrich at Chaska. They were the parents of: Charlotte Virginia (Mrs. Charles Hulbert), Cecile Eugenia (Mrs. Steenson), and Madge Van Norden Hankins.

45

**ALBERTSON-BRYANT HOME.** Robert and Jennie Albertson came to an 80 acre farm in Eden Prairie in 1919. This property is located south of Pioneer Trail by Franlo Road. The Albertsons had six children: Paul, Alice, Margaret, Doris, Mildred, and Mary. Mildred is the widow of Lloyd McConnell. This structure was later the home of the Bryant family.

**MCCONNELL HOME.** The McConnell family came to Eden Prairie in the early 1900s and settled on an 80 acre farm south of Pioneer Trail near Franlo Road. They are of Scotch-Irish descent. Lloyd was their only child. He married the former Mildred Albertson, a neighbor. Mildred and Lloyd were the parents of two sons, David and Paul.

**BOYD FAMILY BARN C. 1989.** William James Boyd was born in Stratford, Ontario, Canada in 1877 and was of Scotch-Irish descent. He married Clara Bell Millett of South Dakota in 1905. Their children were George William, Alice, Ernest, Carrie, Esther, Willard, and Nancy. George helped his father on the Eden Prairie farm on Duck Lake Trail where they had a horse ranch. He married Ruby Mliner in 1938. They are the parents of four girls: Patricia, Maxine, Winifred, and Terry.

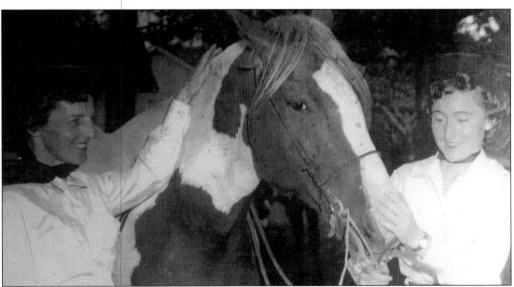

**PAT (BOYD) JENSON AND RODEO CLUB ADVISOR WITH TRICK HORSE "AMIGO" IN 1954.** One of the highlights of the Eden Prairie community from 1950 through 1956 was the Boyd Rodeo. George and Ruby Boyd and their three daughters, spear-headed by their oldest daughter, Pat, formed a club called the "Rodeo Riders." Thousands of dollars were donated to causes such as the cancer fund, Rolling Acres Facility for the Handicapped, and Sister Kenny Institute. The rodeos were a way of involving young people to work together for a common cause, to learn to give something back to the community and provided a much-anticipated community event.

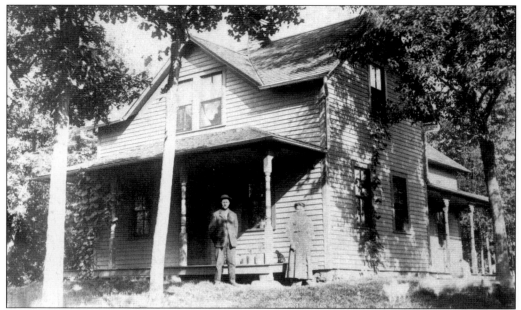

**CHRISTINE AND WILLIAM FRANK KUCHER HOME.** Christine, the daughter of John and Anna Dvorak, married William Frank Kuchera (Kucher) of Eden Prairie in 1889 and settled in the Duck Lake area. Their house was demolished to make way for new housing. William and Christine were the parents of one boy and three girls: May Rose, Frank William, Clara, and Agnes.

**JAMES KUCHER HOME ON DUCK LAKE TRAIL.** This home was rebuilt around 1905 after sparks from a steam engine caught the original house on fire. The old mill for grinding grain was also located on this site. Frank William Kucher (name shortened) married Julia Korbel. They were the parents of Margaret (Mrs. Art Rogers), Clara, William Frank, and James.

**JOSEPH AND OTILIE VISKA.** Joseph and Otilie were married in 1915. They were both from Czechoslovakia and met in Hopkins at the Western Bohemian Fraternal Association.

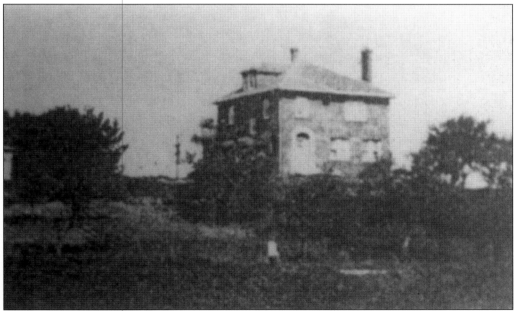

**VISKA HOME C. 1976.** In 1932, the Viskas purchased land in the Anderson Lakes region of County Road 18 and built their dream house. In 1976, the home became the Eden Prairie Historical Center, and the Historical Society was its first tenant.

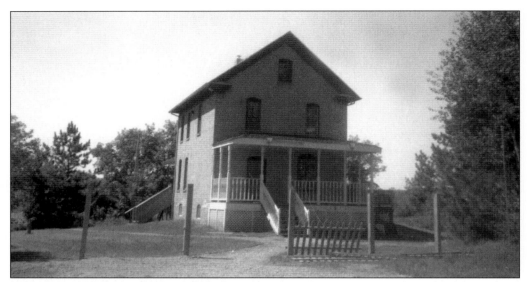

**HOLASEK HOME, NOW CAMP EDEN WOOD, C. 1990**. Joseph Holasek came to America from Bohemia in 1854 with his wife and daughter, Anna. They built a log cabin on the southwest shore of Shady Oak Lake. In 1857, they bought the first land on Bryant Lake where the big brick house built of Chaska bricks stood. It was the birthplace of at least two generations of Holaseks and was bought by Arteka in 1977 for their offices. When Arteka sold the land to Normandale Tennis Club in 1986, the house was moved and donated to Camp Eden Wood, an Eden Prairie camp serving mentally and physically handicapped children.

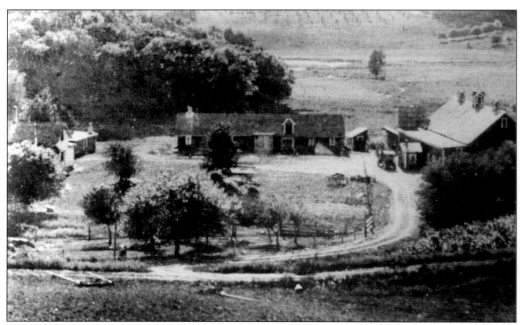

**HOLASEK HOMESTEAD C. 1917**. Holasek bought the first land on Bryant Lake. He chose this land because it was on a lake and had a creek running through it.

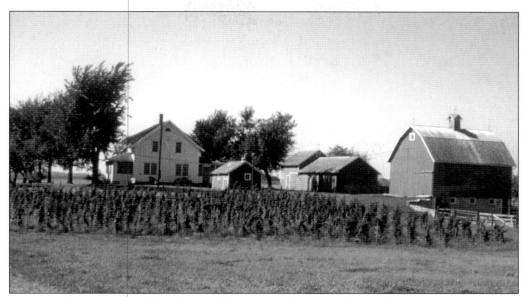

SCHMIDEL HOMESTEAD. The Schmidel family came from Brandeis, Bohemia, to this country in 1853. Joseph Schmidel married Rosalia Souba in 1857. Joseph was a mason by trade and Rosalia helped him. They moved to a farm near Glen Lake in 1868. Joseph also had a sermon book in Czech and conducted prayer meetings in his home. The groups who gathered there were active in the organization of the John Hus Presbyterian Church at Deephaven Junction, now Faith Presbyterian Church.

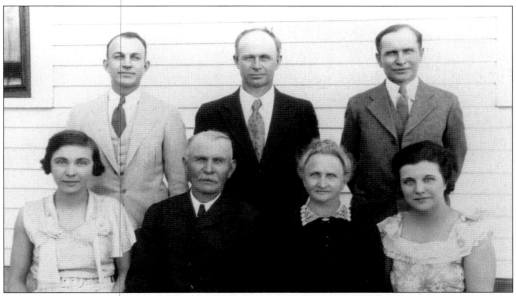

SCHMIDEL FAMILY. Joseph's son, William Schmidel, married Josephine Kucera. Josephine was born in Czechoslovakia. They were the parents of nine children: Albert, Frank, William, Charles, Frederick, Emma, Agnes, Julia, and Ella. They lived on a farm east of Lake Riley in a big nine-room brick house. Joseph loved the soil and was a master farmer. He took active part in the Methodist Church and served on the town board and school board.

**WILLIAM AND EMILY KOPESKY FAMILY.** Pictured from left to right are as follows: (front row) Emily, Vlad, Helen, Harry, Leslie, and William; (back row) Anne, Grace, Emily, Wilma, and William. The Kopeskys purchased land in the Shady Oak area in 1869. Around the turn of the century, the two Kopesky brothers of Czechoslovakian descent married Zrust sisters from Moravia; William married Emily and Frank married Anne. They lived side by side off Shady Oak Road for many years and were both berry farmers.

**FRANK AND ANNE KOPESKY FAMILY.** Pictured from left to right are the following: (front row) Jerry, Bill, Dan, and Emily; (second row) Frank, Hank, Blanche, and Anna.

**HOME OF THE MINNETONKA-EDEN PRAIRIE BRENS.** Ed Bren, grandfather of Richard Bren Sr., settled in Minnetonka in 1854. Richard's grandmother, Anna Bren Filipi, and Alvin Bren's grandfather, Joseph, of Eden Prairie were sister and brother. Richard married Martha who came to Eden Prairie from Canada. Their farm was located west of Round Lake. They have three children: Richard Jr., Barbara, and Bruce. Their farmhouse was originally owned by the Starings. The Brens lived in it until they sold their land to developers in 1980.

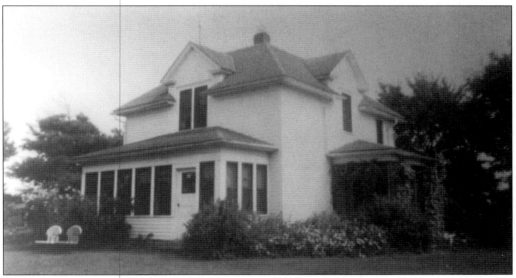

**ALVIN AND MILDRED BREN HOME.** Joseph and Emilie Bren came from Svate Katre'awa, Moravia, in 1881. Mr. Bryant sold Joseph and Emilie their first 80 acres and offered to build them a house, which was constructed by Winslow Dvorak for $40. The farm was bounded by Bryant Lake, Hwy. 169, and Crosstown Hwy. 62.

**JAMES AND LILLIAN ROGERS HOME**. John Rogers persuaded his nephew, James, to come to Eden Prairie in the early 1900s. James married Lillian Bartush from Waverly in 1913. They had been married 63 years when Jim died. They were the parents of: Donald, Arthur, and Richard. Active in the community, Jim served as assessor for Eden Prairie. Following in his father's footsteps, son Donald served on the town board and was the first mayor of Eden Prairie.

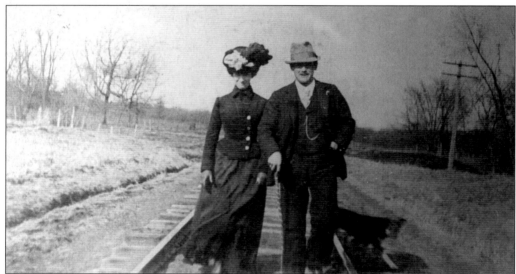

**JOHN AND MATILDA ROGERS**. In 1873, John Rogers, the son of Henry and Anna Rogers, was born in Castle Morton Parish, Worcestershire County, England. He came to Eden Prairie in 1897. He began farming and settled on the Schmidel farm in Glen Lake, later renting pieces of land around Eden Prairie. He married Matilda Melchoir in 1898, and they lived in the Douglas-More home on Eden Prairie Road, where their four children were born: Roland, Harry, Helen, and Alice. They then moved to the Geisler farm on Pioneer Trail. After Matilda's death in 1933, John married Elizabeth Richard.

**LOUIS GEISLER HOMESTEAD, BUILT 1800S.** The Louis Geisler homestead, located on Pioneer Trail west of Eden Prairie Road, was later the John Rogers home.

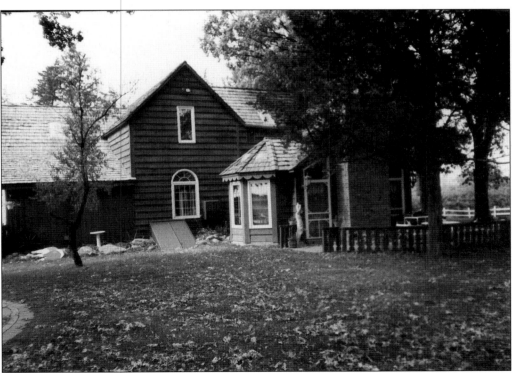

**WILLIAM GEISLER HOME, BUILT 1800S.** In the early 1900s, John and Roland Rogers lived here; in the 1960s, it became the William and Arlene Marshall home, located on Pioneer Trail west of Eden Prairie Road.

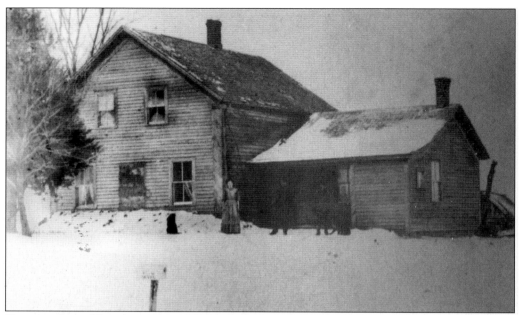

**DORENKEMPER HOME, C. 1800S.** The Dorenkemper home was located on Pioneer Trail. Siding covers the original log house.

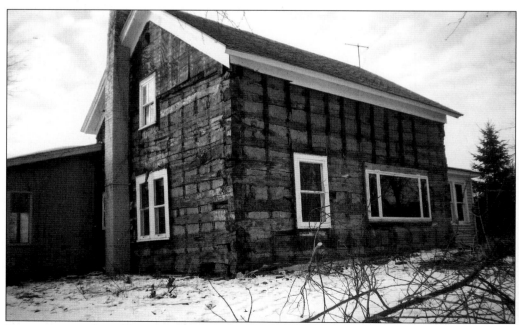

**DORENKEMPER LOG HOUSE, C. 2003.** This is the authentic log house as it appears after the siding has been removed.

**RINAULT AND JENNIE DORN.** The Dorns had three children: Arthur (Pat), Orville, and Marge (Mrs. Donn Schmidel).

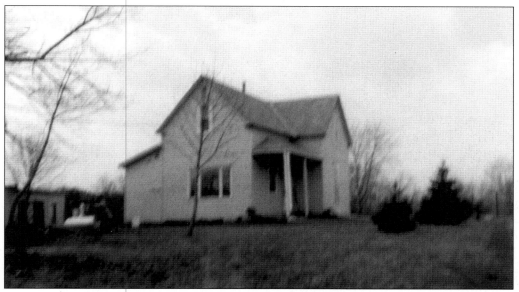

**RINAULT AND JENNIE DORN HOMESTEAD, BUILT 1800S.** The Dorn homestead was located on Pioneer Trail near Riley Lake.

**ROBERT LUCAS SR. HOMESTEAD, BUILT 1800S.** The Lucas homestead was located on Scenic Heights Road near the Methodist Church.

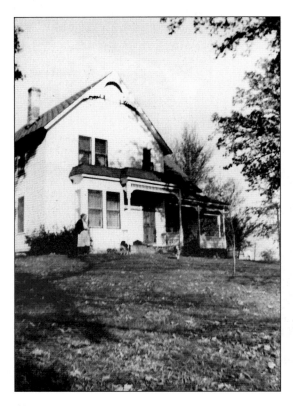

**ROBERT LUCAS JR. HOMESTEAD.** This home was located on Scenic Heights Road behind the home of Robert Lucas Sr. Mrs. Robert Lucas Jr. (Mary Baines Lucas) was a librarian at the consolidated school.

# *Four*
# CHURCHES AND
# CEMETERIES

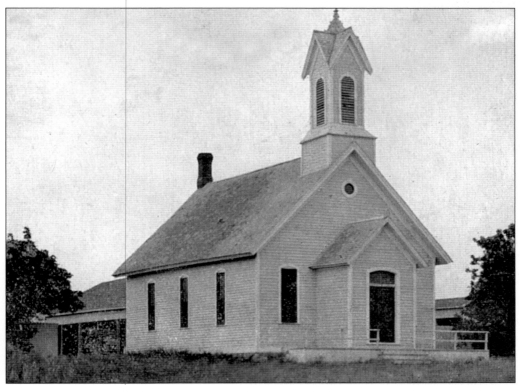

**METHODIST CHURCH.** The first services of the Methodist Church in Eden Prairie were conducted as early as 1853 in the log homes of Jonas Staring, on Pioneer Trail near Staring Lake, and David Mitchell on Mitchell Lake. The new church was dedicated on June 16, 1872, located on land donated by William Collins near the Gould School.

**THE REVEREND HARRISON MACOMBER.**
Rev. Macomber was the pastor of the
church, as well as a carpenter, and handled
the building of the church.

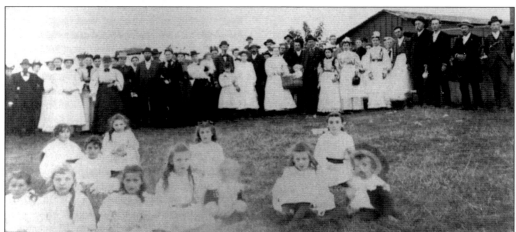

**LADIES AID, C. 1909.** The Ladies Aid was organized November 30, 1892, with the following
charter members: Mrs. Gould, Mrs. J.H. Anderson, Mrs. J.W. Pemberton, Mrs. George Moran,
Mrs. Melvin Baily, Miss Fanny Leigh, Mrs. Stanley Staring, Mrs. Henry Tuckey, Mrs. William
Anderson, Mrs. Andrew Mitchell, Mrs. Albert White, Mrs. J. Curle Sr., and Jennie Anderson
Middlebrook. It served the Methodist church for 48 years. In 1940, it became the Women's
Society of Christian Service, and in 1973, it became known as United Methodist Women. This
picture was taken at the 37th Anniversary and Jubilee Service of the Macomber Methodist
Episcopal Church on June 16, 1909.

NEW CHURCH AT 15050 SCENIC HEIGHTS ROAD, C. 1961. In 1961, Rev. Richard Kuhn became the first full-time pastor in the church's history. That same year, a new church was built on the present ten-acre site at 15050 Scenic Heights Road.

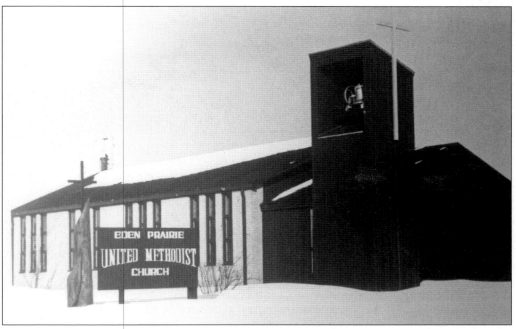

REMODELED AND EXTENDED SANCTUARY, C. 1977. On April 10, 1977, ground was broken for extension and remodeling of the sanctuary. This was made possible by the $25,000 bequest from Warren Shultz. The project included a bell tower, new cushioned pews, carpeting, colored acoustical wall panels, sun screens, a new sound system, and some exterior sanctuary entrance remodeling as well as painting. The church bell was installed at this time with memorial money in memory of longtime church members Nelson Mitchell and Rudy Berger.

METHODIST PARSONAGE ON SCENIC HEIGHTS ROAD.

METHODIST PARSONAGE ON NORTH HILLCREST COURT.

**New Church Addition.** March 12 and 13, 1988, were the dedication dates for the new million dollar sanctuary addition, additional classrooms, and a new electronic organ. The dedication coincided with the 135th anniversary celebration of the Methodist Church in Eden Prairie.

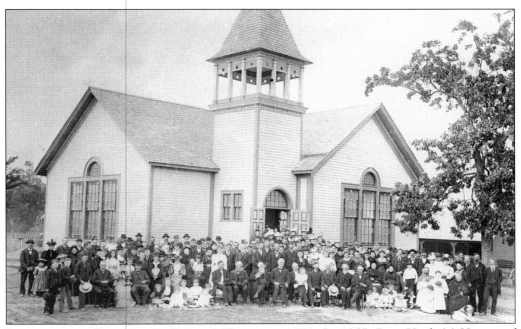

**Presbyterian Church on Pioneer Trail, c. 1893.** In 1855, Rev. Hugh McHatton of Galena, Illinois, came to Eden Prairie. He told the settlers how to proceed about organizing a church. The next summer, 1856, a brother of Rev. Hugh McHatton came from Galena and organized a United Presbyterian Church, which had 24 members. That same year, Jacob Wolf donated land for a church, and by 1869, the church stood on County Road 1 in Eden Prairie.

THE REVEREND JAMES STEENSON.

**MAMIE BROWN STEENSON.** Hometown Presbyterian pastor Rev. James Steenson married a hometown girl, Mamie Brown.

**LADIES AID SOCIETY, C. 1910.** The Presbyterian Ladies Aid Society was later called the Women's Association of the Eden Prairie Presbyterian Church.

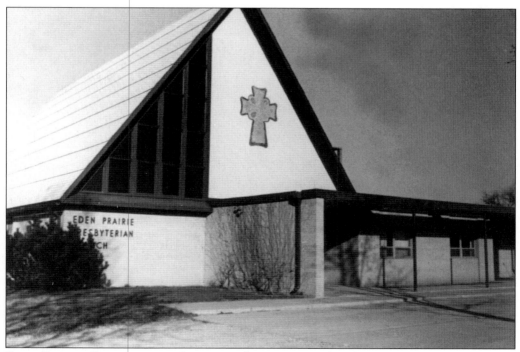

**EDEN PRAIRIE PRESBYTERIAN CHURCH.** This picture of the church, located on Leona and Flying Cloud Drives, dates from c. 1960.

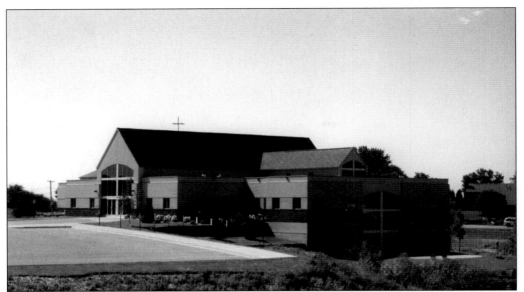

**NEW CHURCH AT EDEN PRAIRIE ROAD AND PIONEER TRAIL, C. 1998.** This Presbyterian Church is the newest church building, located on the corner of Eden Prairie Road and Pioneer Trail. The church welcomes many new members from throughout Eden Prairie and neighboring communities as they follow their vision: "together to celebrate…sent forth to proclaim."

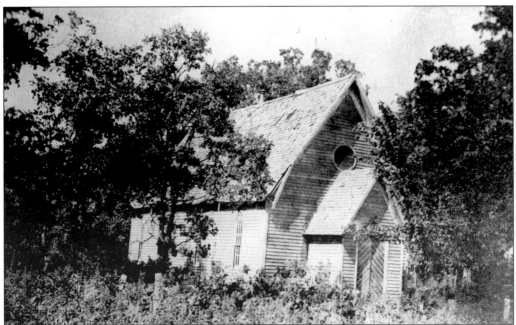

**ST. JOHN'S EPISCOPAL CHURCH IN THE WILDERNESS, C. 1867.** Rev. John A. Fitch officiated at his first service in Eden Prairie on January 22, 1860, in a barn. The Episcopal Church building was moved from Chanhassen to Eden Prairie on a lot donated by J.R. Cummins in 1867, at a present-day site across from the airport on Pioneer Trail. In its earliest days, average attendance at the church was about 30.

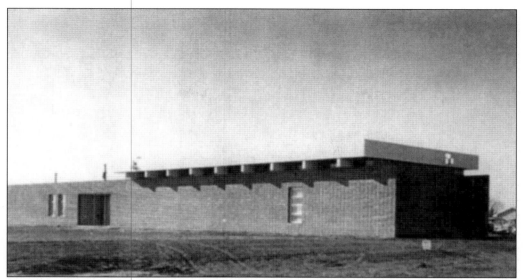

IMMANUEL LUTHERAN CHURCH, C. 1962. In 1961, the American Lutheran Church surveyed the area and determined that a new church was needed in the growing Eden Prairie community. On January 23, 1962, Joseph Simonson was called upon to be Immanuel Lutheran Church's first pastor. Land was purchased near the corner of Eden Prairie Road and Hwy. 5, and a first unit was constructed.

IMMANUEL LUTHERAN CHURCH, C. 1987. An addition to the church, seen in this aerial view, includes major renovations such as a new sanctuary, classrooms, offices, and kitchen.

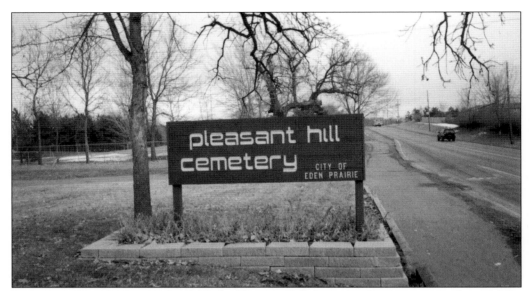

**PLEASANT HILL CEMETERY.** In 1885, the Pleasant Hill Cemetery Association was formed. The cemetery was located north of the Presbyterian Church on Pioneer Trail. It is not associated with the church. Some graves were moved from the Bloomington Cemetery to Pleasant Hill. In December of 1987, the City of Eden Prairie formally accepted ownership of this cemetery from the Pleasant Hill Cemetery Association. This change was made because there weren't enough volunteers interested in continuing the operation of it.

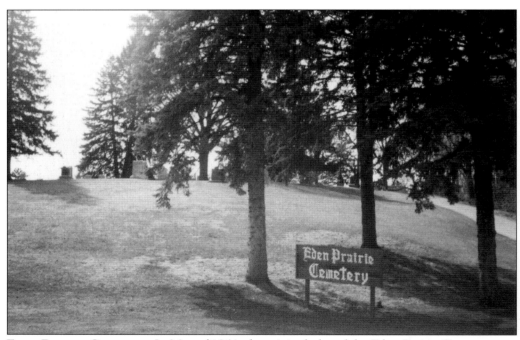

**EDEN PRAIRIE CEMETERY.** In May of 1864, the original plat of the Eden Prairie Cemetery was surveyed. This cemetery is located on a beautiful wooded hillside on Eden Prairie Road. The first records of cemetery meetings begin with March of 1897.

*Five*

# SCHOOLS

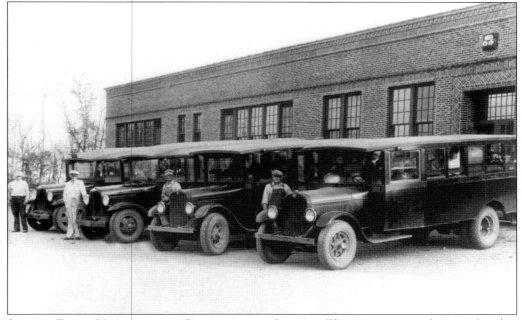

**SCHOOL BUSES USED FOR THE CONSOLIDATED SCHOOL.** This picture was taken on October 15, 1934. It pictures school bus drivers, from left to right, Ted Rogers, Elmer Moran, Everett Moran, and Bill Kutcher.

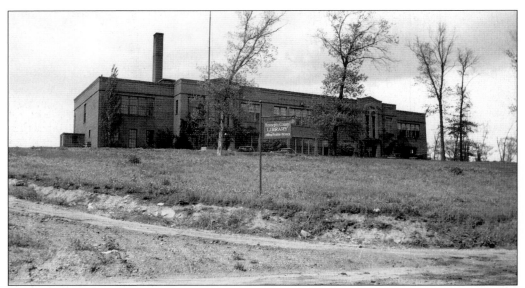

CONSOLIDATED SCHOOL, C. 1924. Four rural schools were built in the 1850s and operated under the supervision of the local town board. They were named after the people who had donated the land or sold it for a small sum, each location is in one of the four corners of Eden Prairie.

In 1860, the boundary lines for the four original school districts were defined as follows: District 56, Gould School; District 55, Anderson School; District 57, Wolf School; and District 54, Jarrett School. Later came Bryant School, in District 60, which was moved to Minnetonka in 1892 and became Shady Oak District 87. There was also the Bush Lake School, built in 1912 for the children in grades one through eight who lived in Bush Lake. It was a one-story structure located at the intersection of County Road 18 and Highwood Drive. The schools built to replace log schools in 1870–1875 were frame buildings.

Around the turn of the century, a conversation began regarding the consolidation of these schools. If this was done, there would be more money for better buildings, teachers, and libraries. On May 29, 1916, the first formal meeting for consolidation was held at Miller's Hall. On September 11, 1916, the special election was held, with 124 votes for consolidation and 26 against. Because of the preoccupation with World War I, the bond drive for the school wasn't made until 1920. This issue passed, but the site for the new school was not put to a vote. It became a very heated issue, as there were several proposed locations. Sheldon Douglas was on the school board, and he and the other board members favored his own property as the site of the new school. Another site was the Wilson Mitchell site at Mitchell and Scenic Heights Roads. Fred Miller offered a compromise site at the location of Art Miller's home on Eden Prairie Road. However, no one was interested in this. The issue was put to a vote and the Douglas site won. Some thought it wasn't a fair election, and a lawsuit followed, but the Douglas site still won.

In May of 1922, construction began on the new school. On March 10, 1924, the four rural schools were closed. Desks and other equipment were moved to the new building, and the consolidated school was dedicated April 25, 1924. The school included eight grades and two years of high school. The juniors and seniors were bused to Hopkins High School. More and more classes were added each year until there was a four-year high school program. The first high school class graduated in 1929. To provide more books in the library, the Hennepin County Library used the school library. The four school buses that provided service were built in Chaska and made of shaped metal and wood. At the time, roads in Eden Prairie were mostly dirt and gravel.

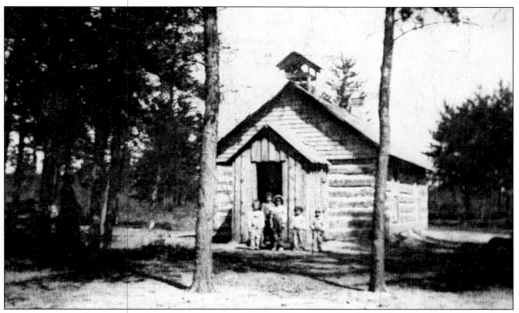

**EXTERIOR OF ANDERSON LOG SCHOOL, C. 1800S.** This was the first school in Eden Prairie.

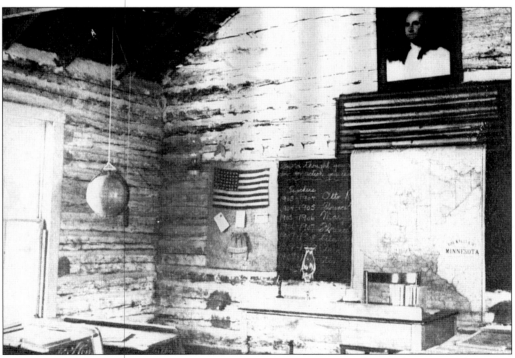

**INTERIOR OF ANDERSON LOG SCHOOL, C. 1800S.** Note the flag and picture of George Washington.

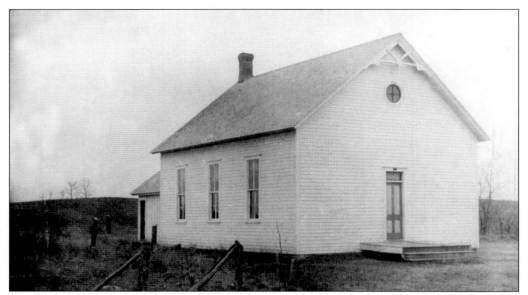

**ANDERSON FRAME SCHOOL, BEFORE 1924.** It was located on land that is now the Sears parking lot in Eden Prairie Center.

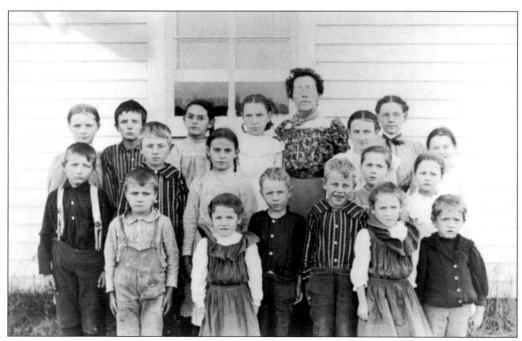

**STUDENTS AT ANDERSON FRAME SCHOOL, BEFORE 1924.**

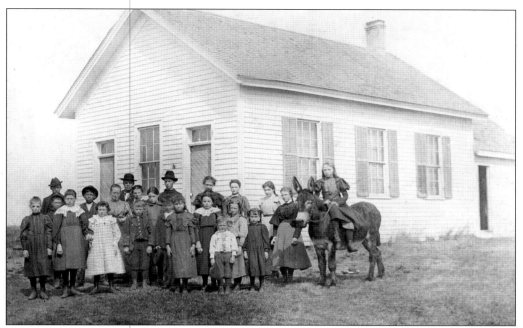

GOULD FRAME SCHOOL, BEFORE 1924.

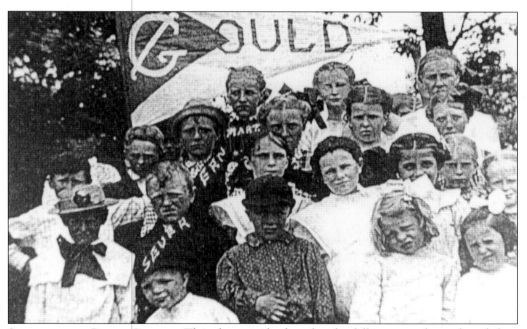

STUDENTS AT GOULD SCHOOL. This photograph identifies the following students, from left to right, as follows: (front row) Elmer Mitchell, Howard Mitchell, Ada Mitchell, and Agnes Morley; (second row) Harold Morley, John Morley, Severin Peterson, Laurine Morley, Rosalie Kelly, Julia Schmidel, Eliese Harrison, and Lorraine Harrison; (third row) Jimmy Neidenfeuhr, Ray Mitchell, Frank Parker, Ernest Peterson, Martha Peterson, Julia Peterson, Jesse Good, Phoebe Harrison, Warren Harrison, Alice Peterson, and Signe Peterson.

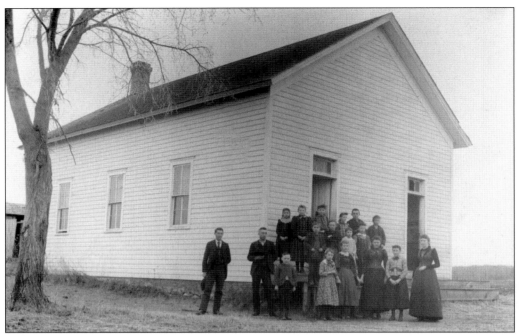

WOLF FRAME SCHOOL, BEFORE 1924. This school was located near Pax Christi Church.

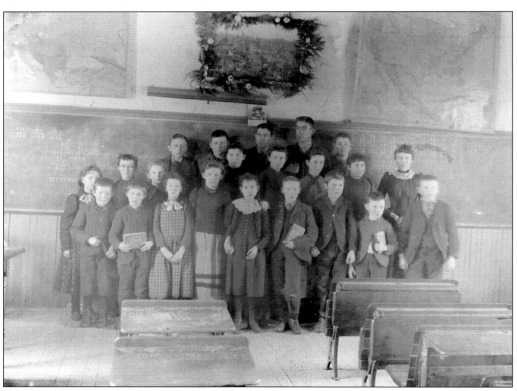

STUDENTS AT WOLF SCHOOL, BEFORE 1924.

74

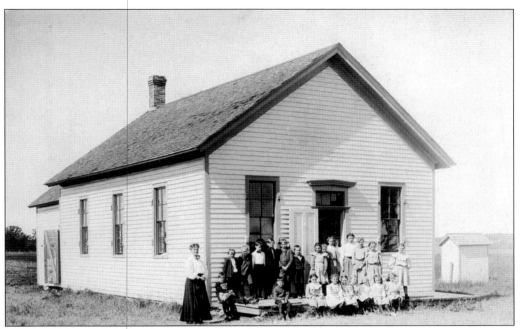

**JARRETT FRAME SCHOOL, BEFORE 1924**. The Jarrett Frame School was located near Round Lake. The building was later home to the Gun Club and American Legion.

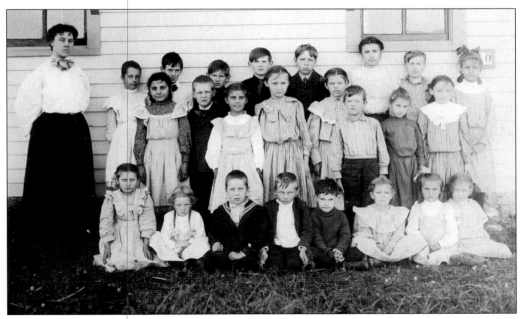

**STUDENTS AT JARRETT SCHOOL, BEFORE 1924**.

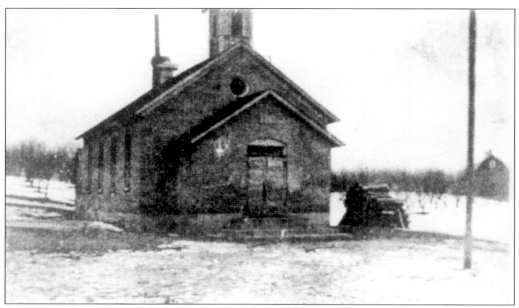

**SHADY OAK SCHOOL.** This school was formerly the Bryant School.

**BUSH LAKE SCHOOL.** Bush Lake School was located on old County Road 18 and Highwood Drive.

**ANDERSON FRAME SCHOOL, C. 1990.** A former home located at 9400 Riley Lake Road has been given to the Eden Prairie Historical Society. The society is in the process of restoring it to its nineteenth century appearance and will use it as a country school for school students to visit.

**GOULD FRAME SCHOOL, C. 1990.** This is now a home located on Pioneer Trail in Eden Prairie.

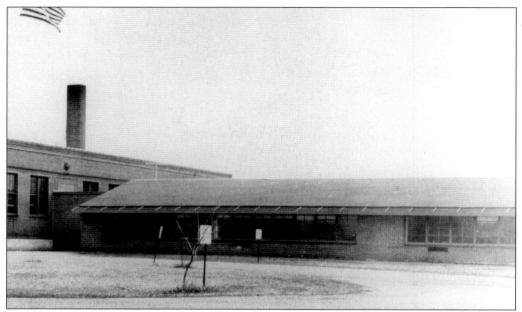

**ADDITION, C. 1950S.** In the 1950s, another vote was put to the people which proposed more classrooms, a new library, a music room, and a manual training room. Consequently, the addition shown in this picture was built on the north side of the consolidated school. The addition was jokingly referred to as "the sheep shed."

**ADDITION, 1955.** A new kitchen, cafeteria, and more classrooms were built on the west end of the building in 1955.

**CENTRAL MIDDLE SCHOOL, 8025 SCHOOL ROAD.** In 1959, a new high school was built near the present consolidated school to make room for a new gymnasium and locker rooms. Additions were created over the years, and the building presently serves as the community middle school.

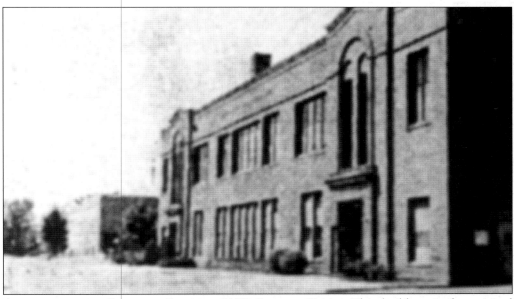

**ADMINISTRATIVE SERVICES CENTER, 8100 SCHOOL ROAD.** This building is the original Consolidated School. The upstairs portion of the building was remodeled in 1982 and again in 1990. Currently this portion of the building is being used for district administrative services. This building was built in 1924. In the fall of 1985, Central Kindergarten Center was also located in this building, and it now has 16 classrooms for kindergarten students.

**PRAIRIE VIEW ELEMENTARY, 17255 PETERBORG ROAD.** Prairie View Elementary first opened its doors in January of 1965. Additions were put on in 1968 and 1980, and remodeling was done in 1990. Prairie View currently educates children grades one through four.

**FOREST HILLS ELEMENTARY, 13708 HOLLY ROAD.** Forest Hills opened in April of 1972. It currently educates grades one through four.

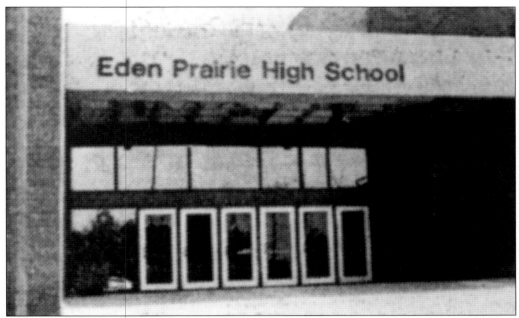

**EDEN PRAIRIE HIGH SCHOOL, 17185 VALLEY VIEW ROAD.** Eden Prairie High School first welcomed students into its doors in January of 1981. A major addition was completed in the summer of 1990. The high school includes grades nine through twelve.

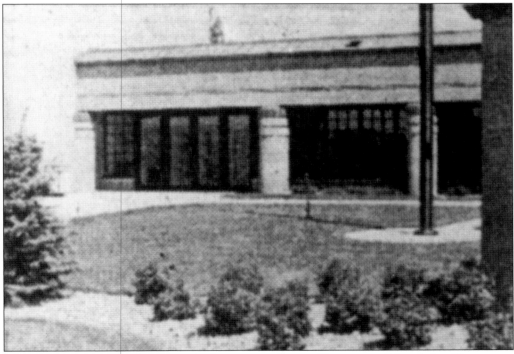

**EDEN LAKE ELEMENTARY, 12000 ANDERSON LAKES PARKWAY.** Eden Lake Elementary opened for students in September of 1987. Eden Lake currently houses grades one through four.

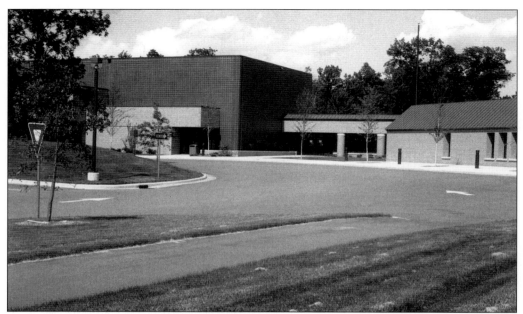

CEDAR RIDGE ELEMENTARY, 16900 PIONEER TRAIL. Cedar Ridge Elementary opened for students in September of 1989. Like the other three elementary schools, Cedar Ridge educates students in grades one through four.

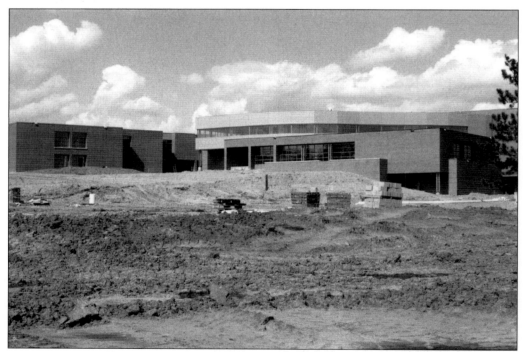

OAK POINT INTERMEDIATE, 13400 STARING LAKE PARKWAY. Oak Point is the newest school in Eden Prairie. It opened for students in September of 1990. The intermediate school includes all students in grades five and six.

**DOTTY D. NYE**. Mrs. Dotty D. Nye was a long-time seventh and eighth grade teacher.

**CONLEY ENGSTROM**. Engstrom was a basketball coach for many years, as well as a memorable math and science teacher.

**CURTIS CONNAUGHTY.** Curtis Connaughty was the first football coach at Eden Prairie High School.

**AL PICHA.** Al Picha designed the first Eden Prairie logo, and it is still used today.

*Six*

# STORES AND
# POST OFFICES

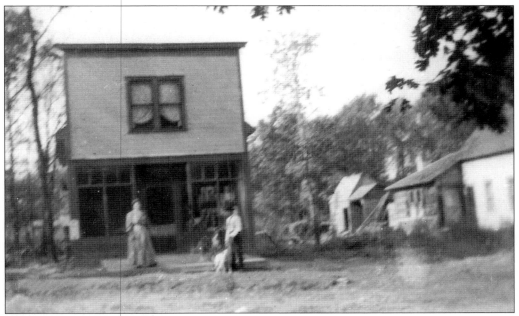

**GOODRICH STORE.** Jonas Staring opened Eden Prairie's first post office in 1854, using the front part of his home on Staring Lake and serving as postmaster. This post office, originally located on what we now call Pioneer Trail, was moved to Horace Goodrich's store when Goodrich built his store and hall nearby.

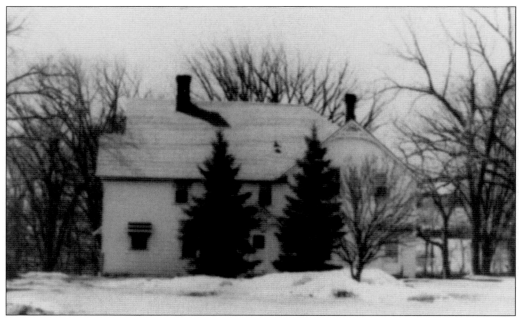

**EXTERIOR OF ROWLAND STORE AND POST OFFICE.** A post office was located in the Rowland Store to serve the northeastern area of Eden Prairie. This was named after the area in Scotland known as Rowland.

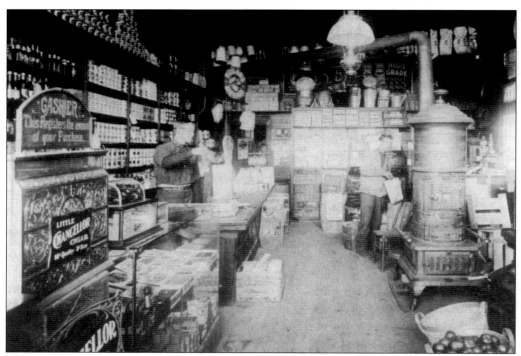

**INTERIOR OF ROWLAND STORE AND POST OFFICE.** This store is located at what is now 7170 Flying Cloud Drive, and it was also the home of the C.L. Sutton family.

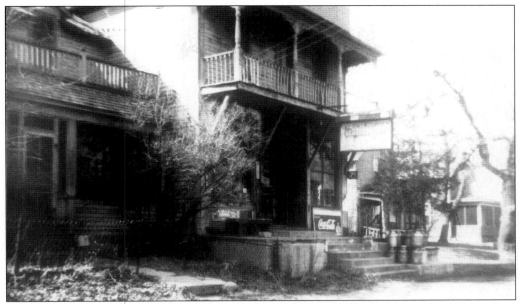

EXTERIOR OF MILLER'S STORE. In 1871, the Washburn Post Office was located in the Rankins Store, which was southwest of the railroad tracks on Eden Prairie Road. Fred Miller bought the Rankins Store and built a new store and hall south of the tracks and re-located the post office there. The name was changed to the Eden Prairie Post Office.

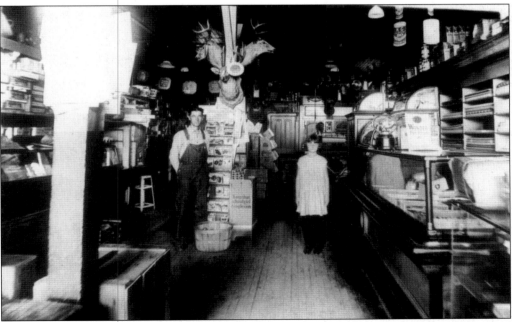

INTERIOR OF MILLER'S STORE. In 1871, when the Minneapolis-St .Louis Railroad was built in Eden Prairie, the mail was all dropped off at the depot located just east of Eden Prairie Road. For 47 years, Fred Miller served as postmaster, then his son, Fred Jr., took over. Ezra Paine and Emil Pauly carried mail, and Harry Neill was mailman for 36 years.

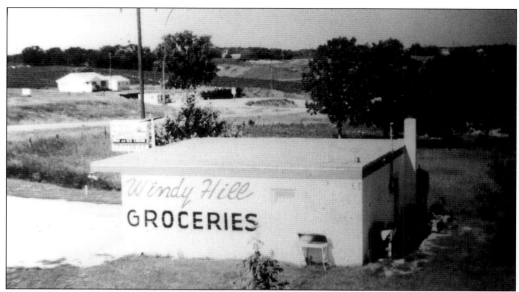

**WINDY HILL GROCERY.** Windy Hill Grocery was the first modern-day grocery store in Eden Prairie, arriving in the 1950s. The store, a family project headed by Zana (Mrs. Harold) Ravnholdt, was located on Hwy. 5 in Eden Prairie, near where the present-day Prairie Lawn and Garden is located. The store was open for many years until the fixtures were sold to William Riegert, who opened the Lil' Red Grocery. Zana now resides in Denver, Colorado.

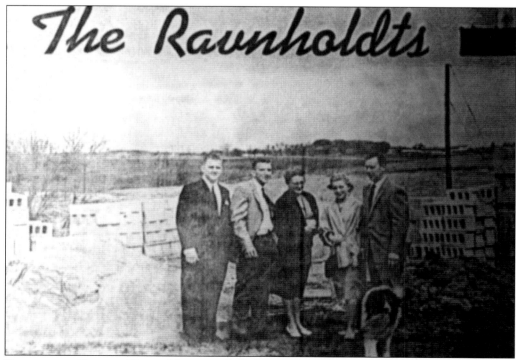

**RAVNHOLDT FAMILY.** Pictured here are Rick, Doug, Zana, Andrea, and Harold.

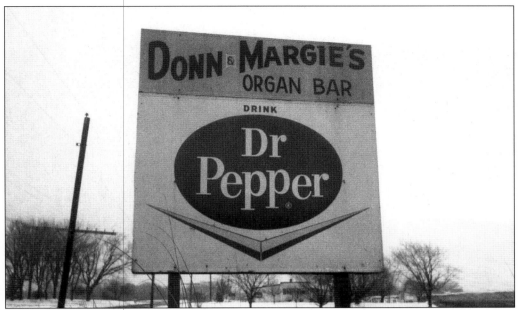

**DONN AND MARGIE'S ORGAN BAR.** This business was located on Pioneer Trail near Dell Road.

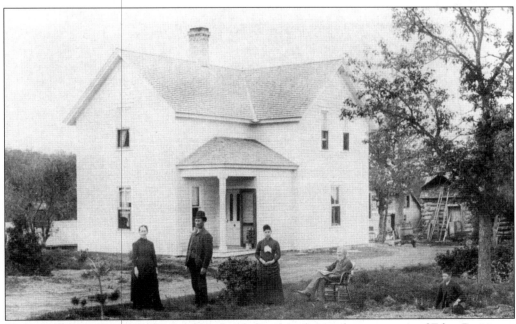

**TUCKEY STORE.** Henry Tuckey and his family lived in the southeastern part of Eden Prairie on Purgatory Creek. In 1895, he opened a store in the front part of his home. This later became known as the Tuckey Post Office. Notice the log cabin at right.

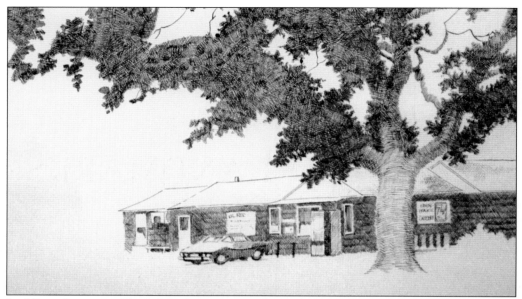

**LIL' RED GROCERY.** The Lil' Red Grocery was located north of Miller's Store. The post office department decided to combine Eden Prairie and Hopkins in 1934. However, Eden Prairie residents did not like having a Hopkins address. In 1965, Eden Prairie was given its own address with a post office set up in the village hall. It was later moved to the Lil' Red, and the new post office is located off Flying Cloud Drive near Anderson Lakes Parkway.

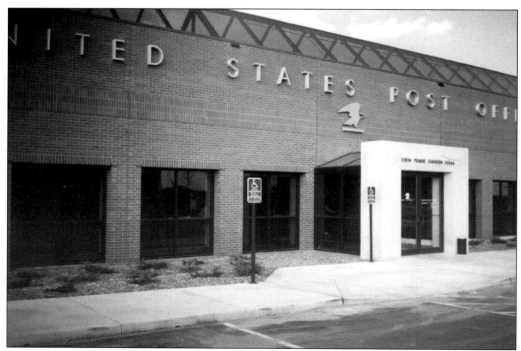

**NEW EDEN PRAIRIE POST OFFICE.** The new post office is located off Flying Cloud Drive near Anderson Lakes Parkway. This post office was finished in 1991.

# Seven
# SITES AND LANDMARKS

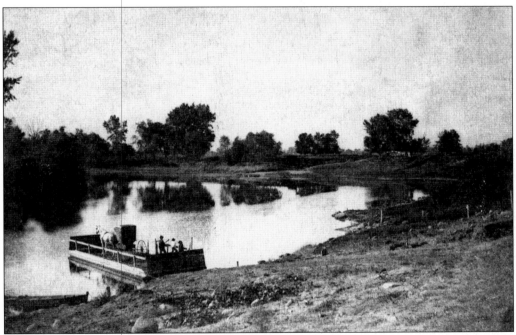

**MURPHY'S FERRY.** In 1856, a law was passed by the Territorial Legislature granting Richard G. Murphy the right to operate a ferry across the Minnesota River at Murphy's Landing. This ferry was run by William Chambers, who was married to Martha Mitchell (the first wedding in Eden Prairie). At that time, County Road 4 was called Murphy Ferry Road because it went down to the landing. This road was very important to the early settlers of Eden Prairie and Shakopee as it was a much better way to cross the river than using the birch bark canoes like the Indians used. Across the river is the site of the present Murphy's Landing in Shakopee, the renovated town of the 1840s–1890s where interpreters wear period clothing to demonstrate life in early times.

**FREDRICK-MILLER SPRING WITH WATER TANK AND SEVER PETERSON II.** In very early times, the Sioux Indians situated their Indian trail to run beside this spring. The trail later became the road to Shakopee. The Indians would bring their loved ones to this spring to drink the water, which they believed restored them to health. This spring water was the remedy they used if the medicine man's brew did not heal the sick. They called it the spring of "minewaucan," which means curing water.

**FREDRICK-MILLER SPRING WITH WATER TANK AND FRANCES FREDRICK.** William Fredrick and August and John Kruger found this spring on the other side of the road in 1890. They dug a trench channeling it to the present site and inverted a large black heavy cast iron butchering kettle over it and capped the flow. A large wooden tank was built to hold the water. This was used for drinking as well as watering stock. The farmers stopped for water for themselves and their horses. This is why we believe the name of the spring should be called "Fredrick-Miller Spring." It was formerly known as Fredrick's Spring to the old-timers of the area. The land was later acquired by the Miller family who donated the spring to the City of Eden Prairie.

**OLD BRIDGE OVER PURGATORY CREEK.** This bridge was built on Pioneer Trail, east of the old Wolf School.

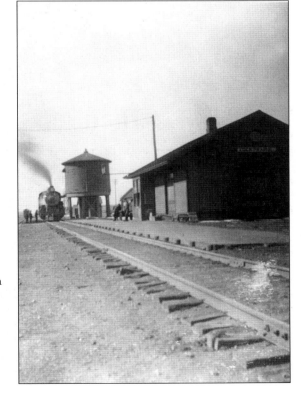

**EDEN PRAIRIE DEPOT AND WATER TANK.** After 1871, a depot was built near the middle of the town east of Eden Prairie Road on the Minneapolis-St. Louis line in Section 17. The first trains had steam boilers and were fired by wood. Piles of wood lined the tracks. There was a water tank and pumping station north of the tracks. The pumper would pump water for the trains.

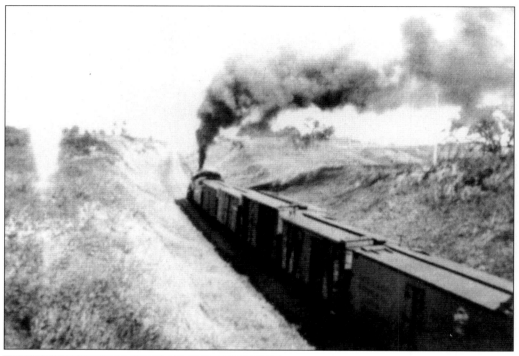

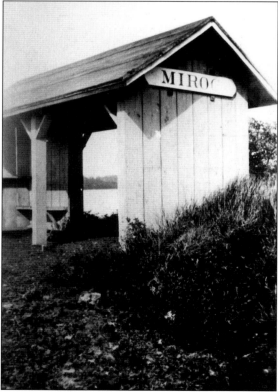

**TRAIN GOING BETWEEN MIROC AND MILLER STATIONS.** In the early 1920s, an organization of Minneapolis businessmen built several cabins on the north shore of Riley's Lake. This was later known as Westminister Heights. At this point, the station was known as Miroc. This was a retreat for visitors—a place where they could swim and relax. They also bought eggs from the area farmers.

**MIROC STATION.** There was a building called Miroc Station, located just south of the railroad tracks and east of Riley's Lake, where people would wave down the train to catch a ride as it went past. This station was removed in later years as the need for railroad traveling became obsolete.

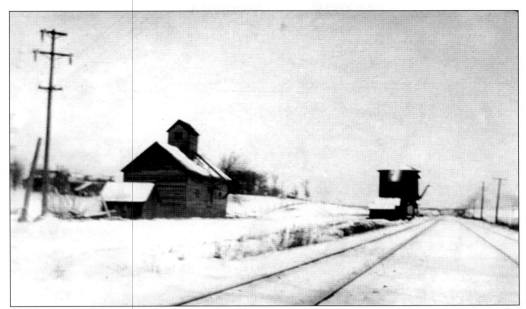

**ELEVATOR.** The Miller Brothers built a grain elevator in 1902. They would buy grain from the farmers and then haul it to the Minneapolis Grain Exchange.

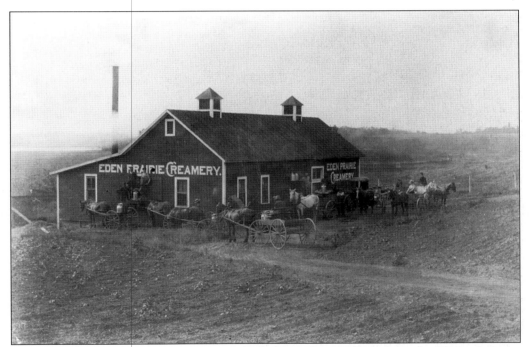

**THE CREAMERY.** In 1884, a creamery was built across from Miller's Store. In 1916, when the Twin City Milk Producers Association was organized, milk routes were taken over by the association. At this time the Eden Prairie Creamery was closed and auctioned off.

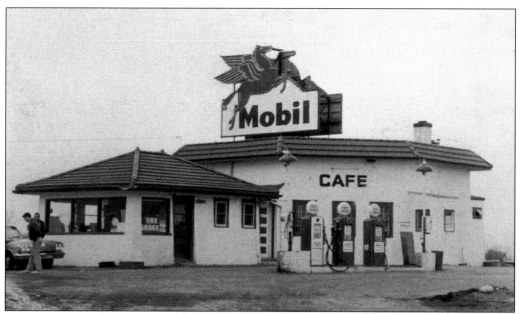

**THE FLYING RED HORSE (MOBIL STATION).** The Flying Red Horse is the large neon sign on top of the Mobil gas station and Davanni's (formerly Wye Café) at the "Y" on Hwy. 212. In the 1970s the Eden Prairie City Council made the sign an official city landmark. In other cases, city ordinances ban rooftop signs of this size. Jesse Schwartz Sr. has been at the hub of this intersection since 1933. His son Jesse Jr. is now the proprietor.

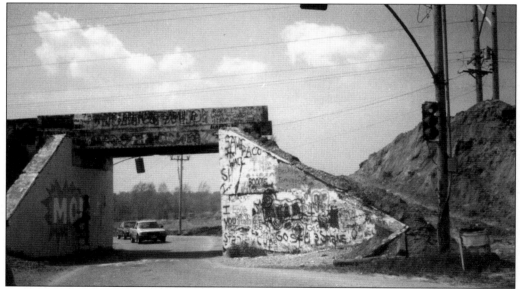

**GRAFFITI BRIDGE.** The notorious Graffiti Bridge of the 1990s is a landmark dating back to early 1900. The one-lane roadway beneath the bridge served as a bottleneck for approximately 11,000 cars per day at the time of its closing. For years the bridge had been painted by people of all ages. There must have been more than a hundred layers of paint on it, probably as much as an inch thick in places. Eden Prairie bid a final farewell to the bridge on May 19, 1991.

LIBRARY, C. 1972. The library located at 7420 Eden Prairie Road was housed in a double Quonset hut. The first library was located in the consolidated school.

LIBRARY, C. 1986. The library located at 479 Prairie Center Drive opened in July of 1986. A new library, to be located just down the street in the old Lund's grocery building, is under construction.

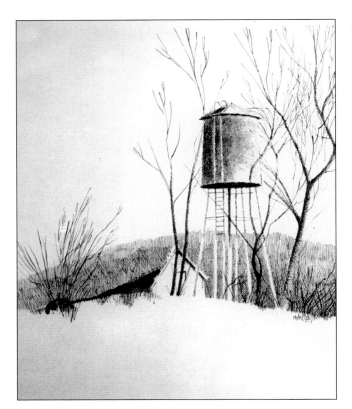

**MILLER'S WATER TOWER.** This water tower was built behind Miller's Store on what is now Eden Prairie Road.

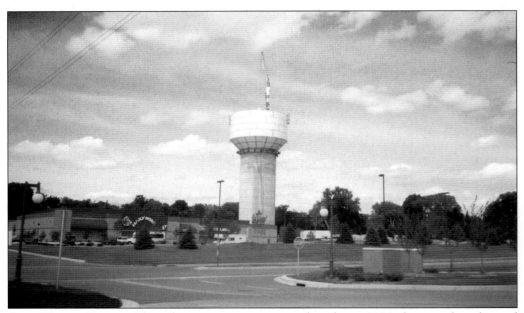

**CITY WATER TOWER.** The other water tower, pictured in this c. 2000 photograph, is located across from the Eden Prairie Center on Hwy. 212.

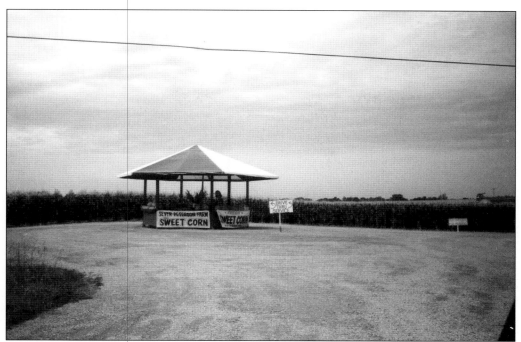

**SEVER'S GREEN AND YELLOW PRODUCE STAND.** Sever Peterson III, grandson of Sever I, and his wife Sharon run this farm operation today, and their stands are seen through the area.

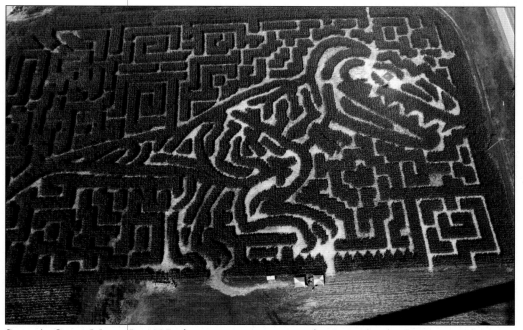

**SEVER'S CORN MAZE.** In 1997, the corn maze came on the scene for the Petersons. That year they fashioned a "T-Rex" inspired by Steven Spielberg's ideas. The maze was located on Hwy. 212 where the old Northrup King was located.

EDEN APPLE ORCHARD. In the mid-1970s, an apple orchard called Appleside West was established on Pioneer Trail and Dell Road. The orchard was purchased by Bill and Arlene Marshall in 1985 as it was adjacent to the hobby farm they had lived on since 1970. They renamed it Eden Apple Orchard. There were 13,000 apple trees and strawberries and raspberries on approximately 100 acres of the land.

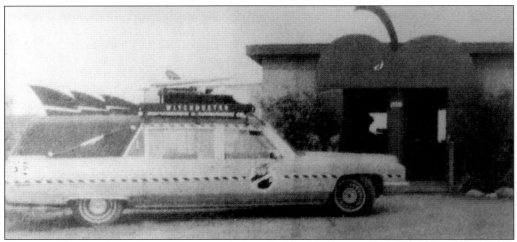

WITCH'S WOODS. In 1991, the Marshall family started a Halloween Hayride through the 40 acres of woods attached to the orchard. Bill wired the woods with electricity furnished by generators, had several sets built, and hired a director to write a script. It became known as the Witch's Woods, and approximately 35 actors performed almost nightly during October. People were pulled through the woods on hay wagons that would stop by each set to watch an act. In 1999, the orchard land was sold for development to Orrin Thompson Builders.

**AMERICAN LEGION, EVERETT MCCLAY POST 409**. The local American Legion Post was started by two World War I veterans, Arthur and Harold Miller, who were both stationed in Washington D.C. when the fist Legion post in the United States, the George Washington Post No. 1, was organized in 1918. The Eden Prairie post was named after Everett McClay who was the first World War I casualty from Eden Prairie. It was organized in 1919 and chartered in 1920. Arthur Miller was commander of the post. Charter members included: Arthur, Fred, and Harold Miller; Roland and Lorman Jarrett; Frank Kucher; Roy Seck; Edwin Manchester; Amos Seiler; Leland Lucas; Henry Kerber; John Harrison; Paul Page; Amos Anderson; George Clark; and Peter Smith.

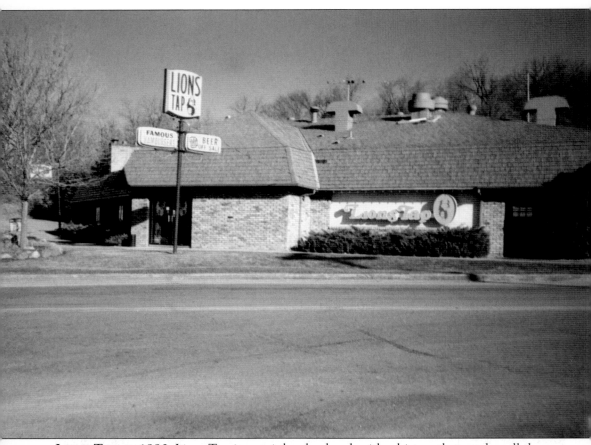

**LIONS TAP, C. 1990.** Lions Tap is certainly a landmark with a history that reaches all the way back to the early settlers in Eden Prairie. Samuel Davis paid the government $114 for a 91-acre parcel in 1885, part of which is the site of this restaurant. In 1932, Severin and Ernest Peterson built a vegetable stand on the site, with beer being offered to the customers just a year later. About four years after that, Mattie Buckingham closed the vegetable stand, and Eden Prairie had one of its first bars. Leonard and Helen Schaefer became the owners in 1950 and served Stewart sandwiches. Eight years later, Helen's niece, Irene, and her husband, Sears Lyons, served the first wonderful hamburgers. Beer was a nickel and hamburgers were a quarter. Lloyd Berg came later, changing the name to Lyons Tap. When Bert and Bonnie Notermann bought the business in 1977, they decided to serve the king of hamburgers and re-named the place Lions Tap. Their quarter-pound hamburgers are definitely a trademark. Bert gets a lot of satisfaction in seeing people come from all over to relax, have a good time, and enjoy his hamburgers. Anyone can feel comfortable in his restaurant—from a guy in a three-piece suit to a construction worker to a student—everyone is in place here. They cater to everybody and certainly have a comfortable atmosphere. How true this has proved to be.

# *Eight*
# ORGANIZATIONS AND BALL TEAMS

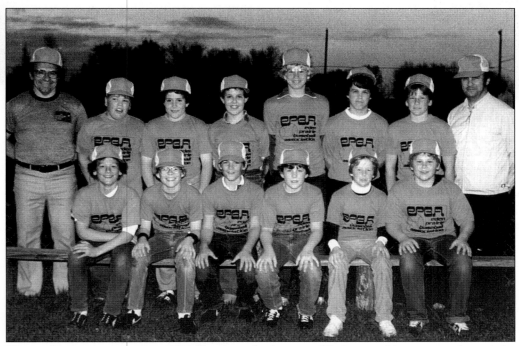

**HARRY BONGARD AND THE 1982 PIRATES.** As they say, "God created heaven, earth, and the BIG INNING!" Harry Bongard, active in baseball for his entire life (he was a bat boy before he was old enough to play), shares this information with us. The Eden Prairie Baseball Association has a team for sixth and seventh graders. Shown is the 1982 Pirates team, which Bongard coached.

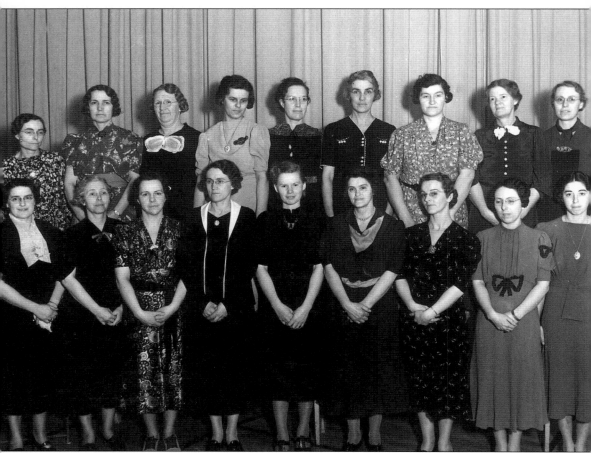

**MOTHER SINGERS CHORAL GROUP, C. 1937.** In the fall of 1930, a group of eight young homemakers met as an informal class studying Child Development and Nutrition using University of Minnesota Extension Course material. In 1931, the Mother's Club was formed. A creed and constitution were adopted in 1933 showing that the purpose of the club had become "to improve home and community life." In 1937, a Mother Singers Choral Group was initiated. In 1938, the members changed the name to the Woman's Club, for they felt, and rightly so, that some women who were not "mothers" might like to join. And they did. The foxglove was chosen as the club flower, and the first program book was printed. Club colors are lavender and gold.

**HELEN ANDERSON.** Helen Anderson organized the Eden Prairie Historical Society in 1969. The Society has been designated by the City of Eden Prairie as the depository of historical information and artifacts for the city. This was done through Resolution 277, April 8, 1975.

**MARIE WITTENBERG.** The author is the president of the Eden Prairie Historical Society. The museum first opened in 1994. That year, when the City of Eden Prairie moved into new offices in the Eden Prairie City Center building, the historical society was given space for a museum. Many artifacts from Eden Prairie are on display there, as well as records and pictures available for genealogy studies.

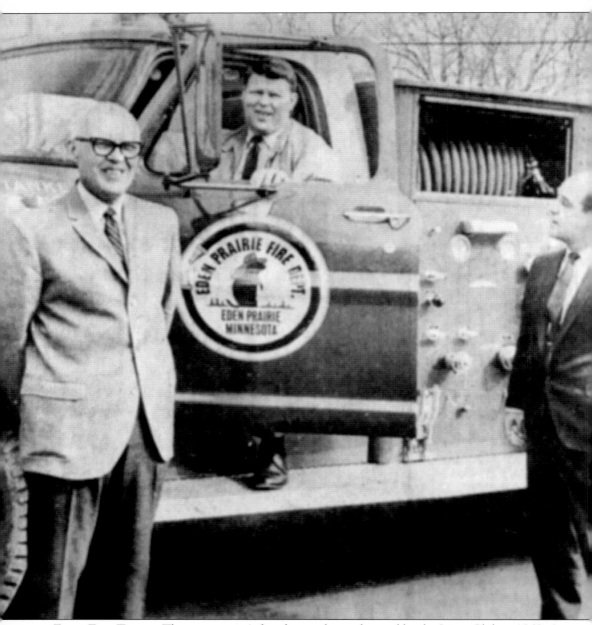

**FIRST FIRE TRUCK.** The community's first fire truck was donated by the Lions Club in 1968. At a special meeting called by the Eden Prairie Council on February 9, 1967, it was overwhelmingly decided to organize a volunteer fire department. Ray Mitchell was elected Chief. Before this time, Eden Prairie was served by Excelsior, Hopkins, and Shakopee fire departments.

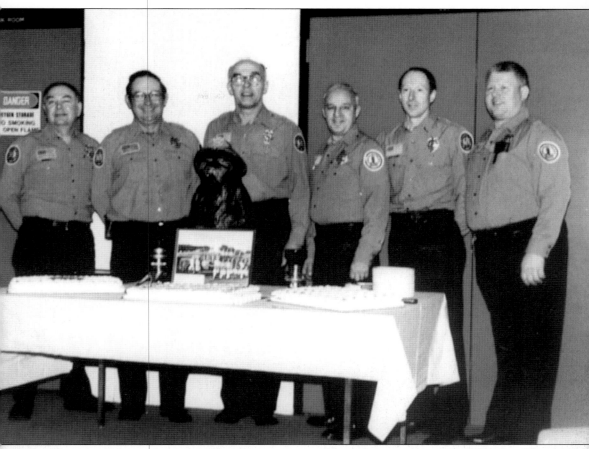

**SIX CHARTER MEMBERS OF THE FIRE DEPARTMENT.** These firemen retired in 1987 after 20 years of service. From left to right, they are as follows: Burton Sutton, Harvey Schmidt, Bert Rogers, Stan Riegert, Skip Lane, and Ray Mitchell.

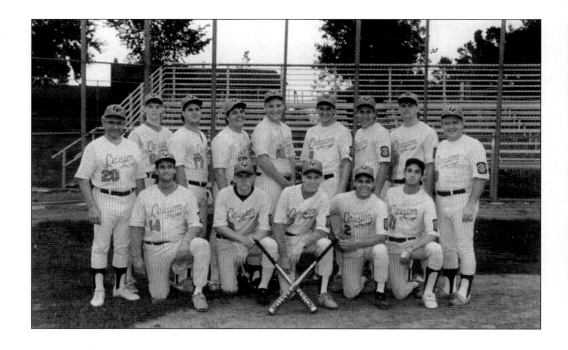

**THE LEGION TEAM.** The Legion team was assembled in the late 1980s for 17 and 18-year-olds. High school and varsity athletes play during the summertime.

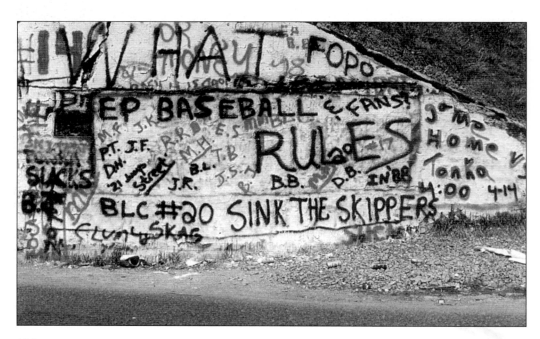

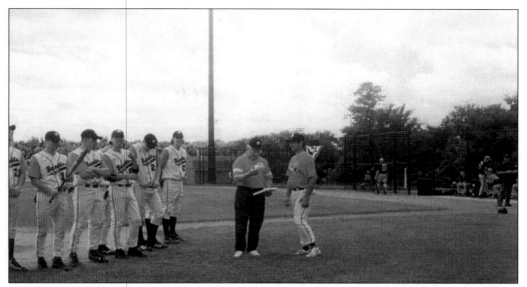

**THE TOWN TEAM.** The Town Team is outstanding for boys 19 years and older. Players join from right out of high school, and they can play for years in this group. They go to state and national tournaments. This team began in Eden Prairie on June 10, 2001, in Miller Park, and Harry Bongard threw out the first pitch. He received a ball signed by all the players and a plaque, which reads: "Eden Prairie's 'Mr. Baseball' presented to Harry Bongard June 10, 2001 in appreciation for over thirty years of service and support of Eden Prairie Baseball EPBA."

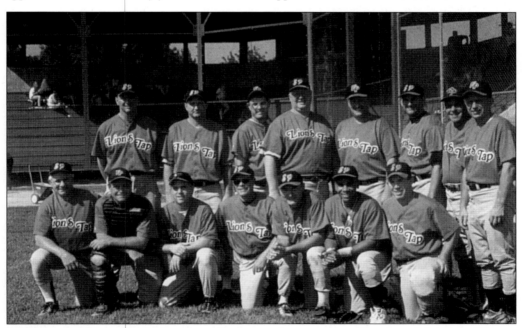

**MINNESOTA SENIOR MEN'S AMATEUR BASEBALL ASSOCIATION.** Founders of the Over-35 team in the Minnesota Senior Men's Amateur Baseball Association 1986 season sponsored by Lions Tap were Pat Thompson and Ron Ess. Thompson was manager and Ess was talent scout and field arranger. The first game was at the Community Center in conjunction with Schooner Days.

**ART MILLER.** Art was an outstanding baseball player in the early days of Eden Prairie baseball.

**JESSE SCHWARTZ SR.** Another accomplished early baseball player in Eden Prairie was Jesse Schwartz Sr.

*Nine*

# GOVERNMENT AND NEW DEVELOPMENT

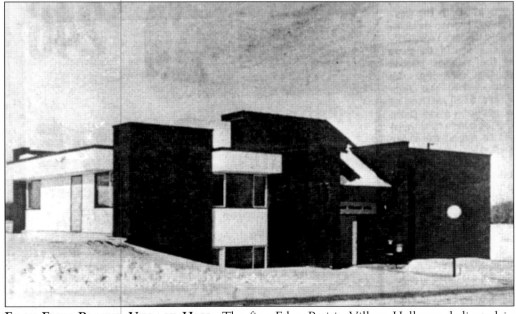

**FIRST EDEN PRAIRIE VILLAGE HALL**. The first Eden Prairie Village Hall was dedicated in March of 1965. The building is located one-quarter mile north of the junction of Pioneer Trail and Eden Prairie Road on Eden Prairie Road.

**EDEN PRAIRIE VILLAGE COUNCIL.** The first meeting of the Eden Prairie Village Council was held in the American Legion Hall on January 8, 1963. Pictured from left are the following: Elmer E. Clark, clerk; Alvin Bren, trustee; Kenneth E. Anderson, trustee; Donald A. Rogers, mayor; and Albert L. Bruce Jr., trustee.

**DONALD ROGERS.** Donald Rogers served as mayor of Eden Prairie from 1962–1965.

112

**DAVID OSTERHOLT.** David Osterholt was elected Mayor of Eden Prairie twice: in 1966, serving through 1971, and in 1974, serving until 1975.

**PAUL REDPATH.** Prior to David Osterholt's second term, Paul Redpath served as mayor from 1972–1973.

**WOLFGANG H. PENZEL.** Wolfgang Penzel served as Mayor of Eden Prairie from 1976–1984.

**GARY D. PETERSON.** Gary Peterson served the City of Eden Prairie as its mayor from 1985–1990.

114

DOUGLAS B. TENPAS. Following the
term of Gary Peterson was Douglas
Tenpas, who served as mayor from
1991–1994.

JEAN L. HARRIS. Jean Harris
followed Douglas Tenpas as
mayor of Eden Prairie from
1994–2002.

**NANCY TYRA-LUKENS.** Nancy Tyra-Lukens is the current mayor of Eden Prairie. She was elected in 2002.

**VIEW FROM PRESENT-DAY HENNEPIN VILLAGE.** This picture shows the beautiful Minnesota River Valley and the city of Shakopee from the site of Hennepin Village. Developer Dan Herbst has begun work on the 250 acres of property located on Spring Road.

**HENNEPIN VILLAGE DEVELOPMENT.** This drawing depicts the public overlook planned for the Hennepin Village Development.

**LIFETOUCH CORPORATE HEADQUARTERS.** An expansion will more than double the size of the Lifetouch Corporate Headquarters buildings. The publishing and photography company, located off Valley View Road, takes school photos of students nationwide.

**SOUTHWEST METRO TRANSIT STATION.** The June 2003 opening of the new Culver's Frozen Custard and Butterburgers Restaurant, just off Technology Drive, is but one of the many welcome additions to the area. Also being constructed are Caribou Coffee, Bear Rock Café, Noodles, Jamba Juice, Chipotle, and Krispy Kreme doughnuts.

**GRACE CHURCH.** Grace Church is located on a 62-acre site south of Pioneer Trail, east of Eden Prairie Road and west of Spring Road.

**THE COMPLEX.** The Complex includes seating for 4,200, sports fields, gyms, a wedding chapel, and parking for 2,000, as well as a food court and banquet facilities. Seventy denominations are included in their church family. The church opened in September of 2002.

# *Ten*
# CITY-OWNED
# PROPERTIES

**JOHN R. CUMMINS.** John (J.R.) Cummins is pictured here with his furniture, hand-made from butternut trees, and a bowl of apples from his orchard. He was born in Ireland in 1834. He came to Pennsylvania prior to 1850 and arrived in Eden Prairie in 1856.

**MARTHA "MATTIE" CLARK CUMMINS.** Mrs. Cummins is pictured with her with her flowers and paintings on the wall. In 1862, John Cummins married Martha (Mattie) Clark, who was born in New Hampshire in 1837. He and his wife had no children.

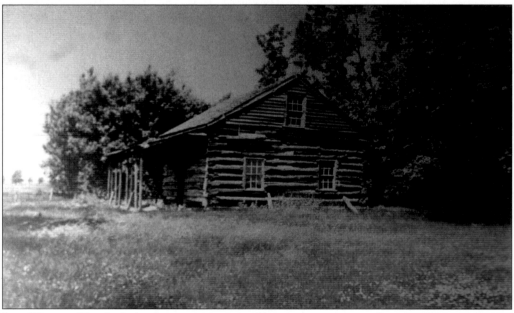

**LOG HOUSE.** This little log house in a grove of butternut trees served as the Cummins home. J.R. cut down the butternut trees and sawed them into lumber for the big brick house he built across the road from the cabin.

**LES KOUBA PAINTING.** The Eden Prairie Foundation commissioned a painting of the home constructed of handmade Chaska bricks. The beautiful and detailed painting was created by the renowned Minnesota wildlife artist Les Kouba.

**PEONY GARDEN.** This 2003 picture shows Gerry Beckman in the beautiful peony garden at the J.R. Cummins homestead.

**MILDRED GRILL IN PEONY GARDEN.** Edwin and Harriet Phipps subsequently bought the farm from Cummins. They had two daughters, Helen and Mildred. Mrs. Phipps put in the lovely peony garden before 1920, with 400 to 500 plants which were purchased directly from Chinese growers who brought them originally from China. Mrs. Phipps' daughter, Mildred, is on the left.

**VEGETABLE GRILL.** The Phipps raised a lot of vegetables, including asparagus, which they sold at their Vegetable Grill built on the Shakopee Hill in 1933. Mildred Phipps married Martin "Pappy" Grill, and they took over the farm. After Martin's death, Mildred sold the land and house to the City of Eden Prairie in 1976. Restoration began in 1982.

**RILEY-JACQUES FARMSTEAD.** In 1853, Matthew O. Riley came from Ireland to Eden Prairie where he settled on the shores of the lake, which would later bear his name, Riley Lake. He purchased 160 acres of land on April 2, 1857. He later purchased additional land north of the original tract. The farm house was built from Shakopee bricks by M. Geisler in 1881.

125

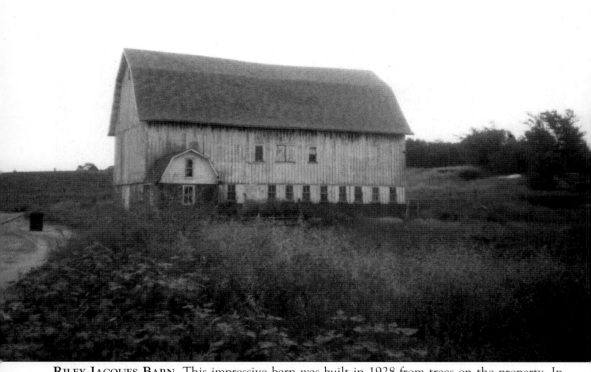

**RILEY-JACQUES BARN.** This impressive barn was built in 1928 from trees on the property. In 1990, 23 acres of this property near the lake was purchased by the City of Eden Prairie to be added to Riley Lake Park. Included in this purchase were the historic Riley-Jacques home, barn, and outbuildings. It is hoped the city will preserve the home and outbuildings, making this an example of an early Eden Prairie farmstead.

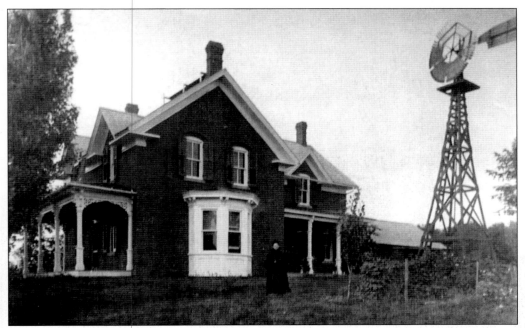

**SMITH-DOUGLAS-MORE HOME, C. 1887.** Sheldon Smith's parents built the red brick house on what is now Eden Prairie Road in 1877. It was built with five rooms upstairs to accommodate travelers who got off the train at the Eden Prairie station. They would get off at the Douglas house and go by stagecoach from there.

**SMITH-DOUGLAS-MORE PROPERTY, C. 1887.** Earl and Helen More bought the Smith house in 1958 and extensively remodeled it. In 1981, the City of Eden Prairie purchased the house from the Mores, who in turn retained a life tenancy.

DUNN BROS. COFFEE, C. 2002. The Smith-Douglas-More house became home to the Dunn Bros. Coffee business on December 30, 2002.

DUNN BROS. COFFEE CARD. The coffee company celebrated their new home in the Smith-Douglas-More house by announcing special offers to the people of Eden Prairie.